IMAGES
of America

MONTICELLO

The first plot of Monticello was made in 1834 by John Barr. The 92 lots were laid out in an eight-block rectangle with a public square near the middle. On the east side along the river was Tippecanoe Street running north and south. It was later renamed Bluff Street. Illinois Street bordered the west side. The south was bordered by Jefferson Street and the north by Marion Street. Main Street ran north and south. Running east to west in the middle was Main Cross Street, which was later renamed Broadway Street. Lots were generally 60 feet by 165 feet. (Courtesy White County Historical Museum.)

On the cover: When the Monon Railroad ran through Monticello, it stopped at this train station at 119 South Railroad Street. The Monon quit running passenger trains in 1959. The station fell victim to the 1974 tornado. The railroad tracks were removed in 1994 by CSX. (Courtesy White County Historical Museum.)

IMAGES
of America

MONTICELLO

W. C. Madden
Introduction by Mayor Robert E. Fox

ARCADIA
PUBLISHING

Published by Arcadia Publishing
Charleston SC, Chicago IL, Portsmouth NH, San Francisco CA

Printed in the United States of America

Library of Congress Catalog Card Number: 2007923218

For all general information contact Arcadia Publishing at:
Telephone 843-853-2070
Fax 843-853-0044
E-mail sales@arcadiapublishing.com
For customer service and orders:
Toll-Free 1-888-313-2665

Visit us on the Internet at www.arcadiapublishing.com

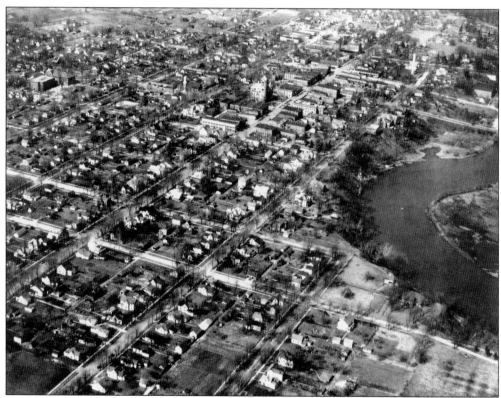

This aerial view shows Monticello before the 1974 tornado. Note how the Tippecanoe River starts a horseshoe bend just south of the Washington Street bridge. The old courthouse stands tall in the middle of the photograph as well as the old standpipe to the right of it. (Courtesy White County Historical Museum.)

CONTENTS

ACKNOWLEDGMENTS

This book was made possible with the cooperation of the White County Historical Museum, which gave me permission to scan any photographs within its museum and use them in this book. The staff of the museum was also very helpful in providing me information or pointing me in the right direction to gather information for this book.

I would also like to thank many others who provided images for this book. The City of Monticello gave me permission to scan its collection of postcards, and staff members gladly provided information about the city. Sue Erb of Jerry's Photography provided some excellent images. Roth Jewelers loaned a couple of historic photographs. The Cottage Shops furnished an old photograph of its building. Several churches contributed old photographs of their buildings for the book. The images of Indiana Beach were offered by owner Tom Spackman Jr. Jan Lindborg donated several photographs too. Steve Buyer's office provided a photograph of the congressman and his biography. The Monticello-Union Township Public Library was of great help in providing information about the city and county. Many civic organizations and the Monticello Chamber of Commerce and Visitors Bureau also provided photographs and assistance. And thanks to other individuals who provided photographs and information for this book.

INTRODUCTION

I was completely humbled when author W. C. Madden asked me to write the introduction for this Monticello book. As a longtime Monticello resident and the current mayor, I am honored to live and work in this wonderful community. Thank you for this book and the opportunity to share insight into what makes Monticello unique.

Before Monticello, the Potawatomi Indians lived in the area. Settling along the western banks of the Tippecanoe River, these Native Americans discovered the bounty afforded by river life: abundant food and the ability to navigate the river to other settlements. In 1829, the first white settlers arrived in Monticello and were greeted by the friendly Potawatomi tribe. These early settlers were from Virginia, New York, Kentucky, Ohio, and Pennsylvania.

Then in 1834, the Indiana legislature created a new county named for Col. Isaac White, a hero in the Battle of Tippecanoe. County commissioners then selected a spot on the west bank of the Tippecanoe River for the county government seat and named it Monticello in honor of the home of Pres. Thomas Jefferson.

The first industrial development in Monticello came in the form of a gristmill, followed by a sawmill, a woolen mill, and a furniture factory. In 1853, the town was incorporated. The following year, more settlers arrived in our community, not via the rivers but by rail. That year, the Louisville, New Albany, and Chicago Railway laid track in White County and Monticello grew.

During the Civil War, Monticello's economy boomed because it was secure from the ravages of war. At the end of the century, the city waterworks began operating. An open well was the source of the city water supply. Monticello became a city in 1909, and the town council was replaced by a mayor and city council. A clerk-treasurer position was created as well.

In the 1920s, two events occurred that changed the character of Monticello. In 1923, the Norway Dam north of the city was completed, creating Lake Shafer. Two years later, Oakdale Dam south of the city was built, starting Lake Freeman. The twin lakes and the Ideal Beach quickly established Monticello as a major tourism attraction. Many visitors ended up purchasing homes in our community and eventually relocating here.

On April 3, 1974, the face of Monticello was changed forever. At 5:17 p.m., a devastating tornado ripped through our midsection destroying everything in its path. Schools, businesses, farms, homes, and the historical limestone courthouse were destroyed. There was an estimated $100 million in damage. Eight people lost their lives that day, and many others were injured.

This tornado destroyed buildings but not the spirit of the community. Days following the tornado, Robert G. Fisher, publisher of the *Monticello Herald Journal*, wrote, "We shall win this

battle and without panic. We all face an awesome task of rebuilding and with it goes great responsibilities. We will not lose for ours is the strength and power to overcome. With God's help your great efforts, common sense and good judgment all along this way to recovery. Monticello will win and could emerge more beautiful that she was before the tornado."

Adversity united our citizens, and we rebuilt the city. The community emerged stronger. And I believe that today Monticello is more beautiful than ever. In early spring, city streets are lined with blossoming trees planted after the tornado. Many historic homes survived the tornado and are treasured as they provide a link to the past. Today lovely city parks welcome residents and visitors. The vibrant downtown welcomes all with planters, banners, and a picturesque setting.

Tourism was and continues to be one of the community's finest assets. Annually 1.3 million visitors come to White County, most of them to enjoy our twin lakes and Indiana Beach, a family-owned amusement park and one of Indiana's premier attractions.

Nowadays Monticello is a vibrant community. Our citizens choose this community not just as a place to live but as a way of life. We are a faith-filled community. Our streets are safe. Our schools are good. This community is strong. Citizens unite to improve the community. We celebrate our achievements. We stand strong in the face of adversity. We cherish this city we call home.

The character of Monticello citizens is constant. Those who rebuilt this city instilled in their children and grandchildren the knowledge that living in this all-American city is a blessing. Monticello has heart and a quality of life that cannot be duplicated. The city continues to rely on God's help, great efforts, common sense, and good judgment.

—Mayor Robert E. Fox

Pictured here is Mayor Robert E. Fox. (Courtesy Jerry's Photography.)

One

Early History of Monticello

When Monticello was founded, not one home was located in the area selected, but the land was owned by the three settlers: Robert Rothrock, Hans E. Hiorth, and Joseph Barr Sr. The commissioners purchased the land from the trio. Other early settlers in the area included Peter Price, George Barkeley, Zebulon Sheetz, Robert Armstrong, and Peter Martin.

In the early days of Monticello, it was not unusual to see Native Americans come to town to trade ponies, beads, or trinkets for goods or to get drunk on whiskey, so the town became known as a whiskey-soaked town. Deer also made their way into town during the winter. They were of value to hunters, who got $1 to $3 for a pelt. However, the scalps of wolves were a lot more valuable. Farmers wanted to get rid of the marauding creatures that attacked their sheep and other animals.

The town was somewhat "wild" at first as grass grew in the streets and weeds covered vacant lots. Cattle, horses, sheep, and hogs roamed the streets at will. Monticello took on a village form of government in 1854, but it only lasted a year. Then it began to transform itself into a town with valuable lots, street improvements, and ordinances, such as a law fining anyone who allowed their horses, pigs, or mules to run wild.

When the Civil War began in 1861, the Monticello Rifles was formed under the command of Capt. Alfred Reed. It joined the 20th Indiana and served for four years in several Civil War battles—Gettysburg being the most famous.

The city got its first fire department on March 11, 1869, when the Monticello Hook and Ladder Company formed with 11 volunteers. The town also purchased a four-wheel wagon equipped with a ladder and buckets the same year. Fires were a problem because most buildings were made of wood. On January 31, 1889, an early morning fire destroyed John Peet's Saloon, Gow's Cigar Store, and Pettit's Restaurant. It was thought the fire was started by a lamp exploding or a cigar stub left on the floor.

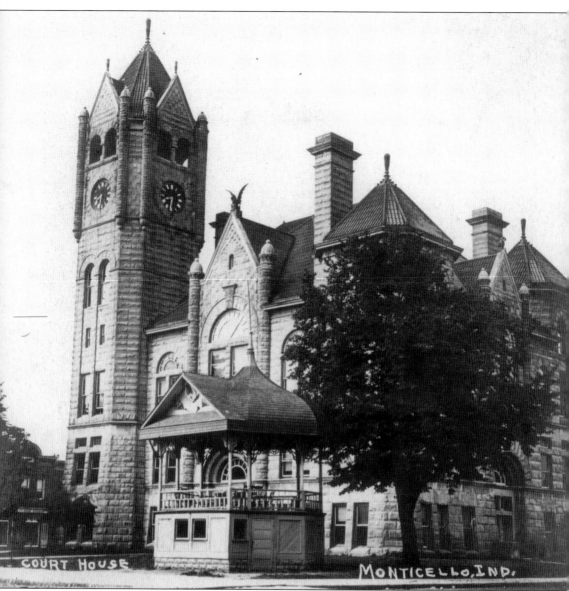

The third White County Courthouse (above) was built in 1894. The limestone structure served the county for 80 years until it was damaged beyond repair by the April 1974 tornado. After the structure was torn down, the cornerstone was opened; it contained Masonic ritual bottles filled with oil, wine, and barley; a Bible; a book about the 46th Civil War Regiment; a horseshoe; currency; medals; and documents. For the county's first courthouse, Robert Spencer was employed in 1836. He started the project, but the frame was blown down in a storm. So Jonathan Harbolt was hired to build another courthouse, and he completed it in 1837. In 1848, work began on a larger courthouse by George Brown of Lafayette. However, his progress on the new brick structure was slowed by an outbreak of cholera. Like many of his neighbors, Brown fled the town to the country to avoid the disease. Business in Monticello was entirely suspended, and it was almost deserted in the wake of the scare. So the new courthouse was not completed until 1851. The two-story brick structure had a 50-foot wooden dome. (Courtesy White County Historical Museum.)

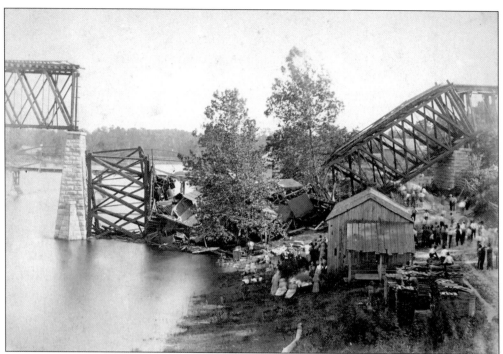

A railway disaster occurred on July 17, 1878, when the Pennsylvania Railroad bridge collapsed under the weight of a train. Two men—an engineer and watchman—were killed in the tragedy. Pennsylvania Railroad freight No. 13 proved to be unlucky when the bridge collapsed, sending the 25 freight cars into the Tippecanoe River. The bridge was originally constructed in the 1850s. (Courtesy White County Historical Museum.)

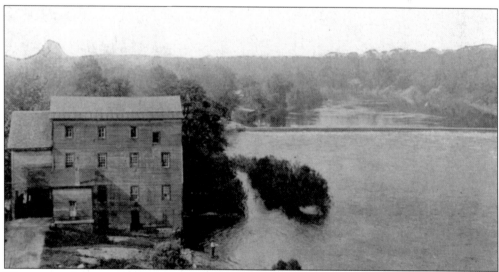

This postcard shows an old Monticello flour mill on the Tippecanoe River south of an early dam in the late 1800s. The first industrial development in Monticello came in the form of sawmills and gristmills along the river. The old dam was covered over when the Oakdale Dam was built and the level of the river was raised. (Courtesy City of Monticello.)

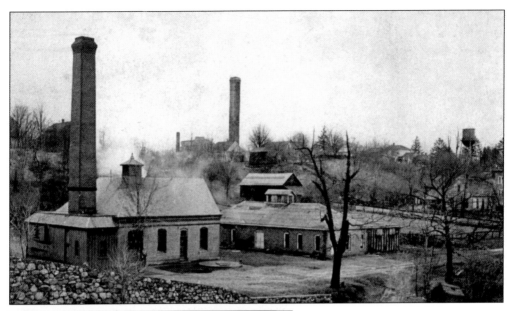

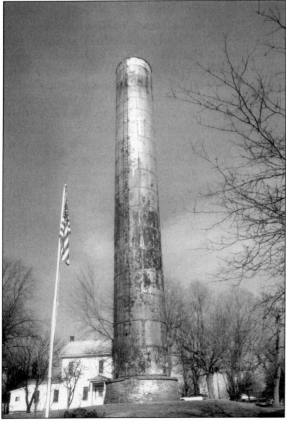

The Monticello Water Works began operating in 1895 when a contract of $28,000 was awarded to Mansfield and Allen of Indianapolis. Col. C. A. Winn was employed as its first superintendent. The pumping station was located at the foot of the bluff just south of the Washington Street bridge. An open well was the source of the city water supply. Also built in 1895 was the standpipe (at left), which was the first water tower in the city. Built by the Chicago Iron and Bridge Company, it is no longer used by the city but still stands high above the city. Rod Pool has been the superintendent of the waterworks since 1984. (Above, courtesy White County Historical Museum.)

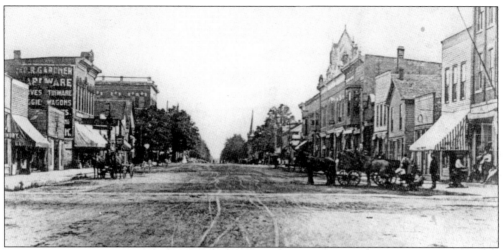

Horses and buggies ruled Main Street back in the 1800s, as seen in this postcard, and the street was made of dirt. This view looking south shows the courthouse and Monticello United Methodist Church on the right, or west, side of Main Street. On the east side is E. R. Gardner Hardware Store and the Hotel Forbis. (Courtesy City of Monticello.)

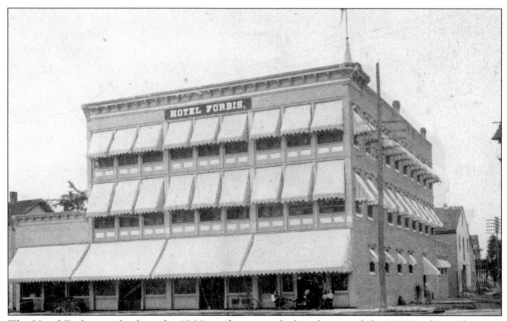

The Hotel Forbis was built in the 1800s and remained a hotel up until the 1960s, when it became an apartment building known as Forbis Flats. It contained 44 hotel rooms. Today the apartments on the second and third stories are known as the Harrison Apartments. Other stores now occupy the first floor, including the New Life Christian Bookstore, Artistic Hair Studio, and the Perfect Blend, a coffee shop. (Courtesy White County Historical Museum.)

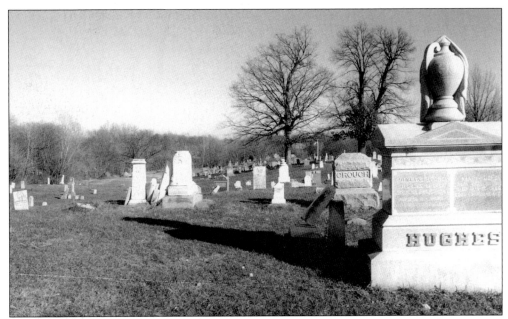

The Monticello Cemetery on St. Marys Street dates back to the early 1800s. White County appointed Zebulon Sheetz, John Ream, and William Sill as trustees of the graveyard back in the 1830s. A tombstone there honors the memory of Delia Van Voorst, who passed away on September 15, 1824. More than 1,000 people are buried there, including World War II veteran William P. Fowler, who was an army sergeant.

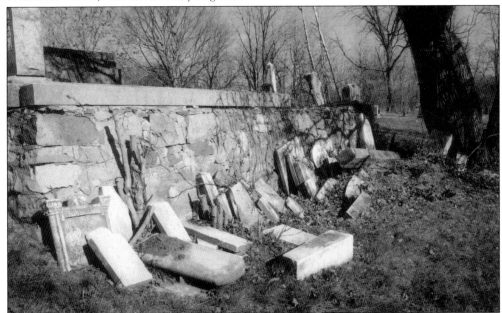

Old tombstones are piled up behind a wall at the old Monticello Cemetery, which is not used much anymore. Much confusion on where to put the tombstones occurred after the 1974 tornado. The last burial occurred there in 1995. One tombstone there honors "Geo. V. Coen, Co. H, Kans. Cav.," which was likely from the Civil War. There are family plots there for Nicholas, Loughry, Clapham, Sanderson, and many more.

14

Troops from the 7th Infantry crossed the Tioga Bridge by horseback in the late 19th century around the time of the Spanish-American War. White County furnished a company of men, the 161st Indiana Volunteers, to the war. The unit lost six men in Jacksonville, Florida, on its way to Cuba, where it did not see much action. Dr. W. E. Biederwolf of Monticello served as a chaplain and historian. (Courtesy White County Historical Museum.)

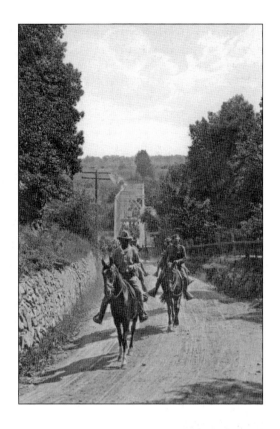

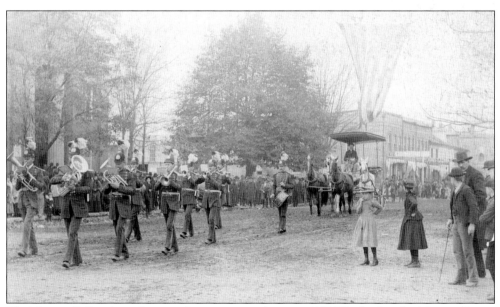

The Monticello Band marches past the county courthouse in 1893. The first band in Monticello was organized in 1852. Dr. Robert Spencer was the leader, and he played the clarinet. It was succeeded by the Monticello Silver Cornet Band. (Courtesy White County Historical Museum.)

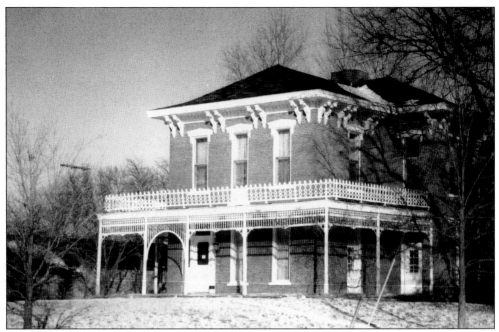

The James Culbertson Reynolds house was built in 1873. It was the first farmhouse in Monticello, according to Clifford Boran, a descendant of Reynolds, who lives in the home now. The Italianate-designed home at 417 North Main Street is on the national register. Boran runs the Antique Stove Information Clearinghouse at the home.

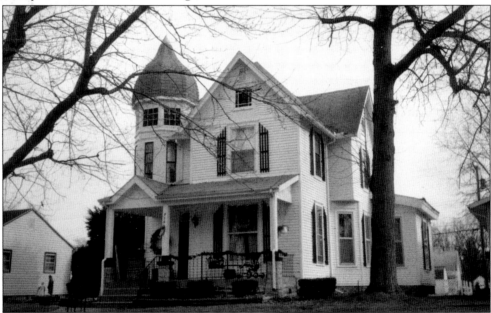

The Samuel Young house on South Bluff Street was built by the architect in 1895. He built several other Queen Anne–designed homes in Monticello as well as many government and commercial buildings around the city. The house is now owned by Juanita Fishel, who says it was an apartment house before she bought it some 40 years ago. The home has four bedrooms and two bathrooms.

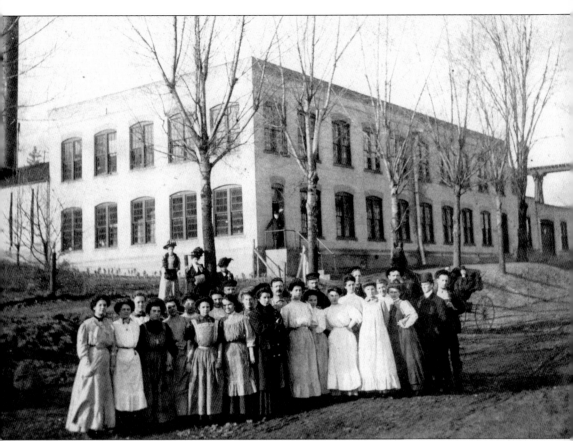

Workers of the Chicago Thread Manufacturing Company take a break from their job for this photograph in the late 1800s. It was one of the first large companies to establish itself in Monticello. It built this factory alongside the Tippecanoe River in north Monticello. Chicago was later dropped from the name. It was extremely busy during World War I when the competition from Europe was cut off. In 1933, an unsuccessful robbery attempt occurred. The company went out of business in May 1940 and moved to Gastonia, North Carolina. Bryan Manufacturing later took over the building and built an addition in 1950. The building suffered damage during the 1974 tornado. Bryan closed its doors in December 1980 after an economic slump in automobile sales and left 162 people jobless. Nowadays the building is used as a warehouse for several purposes. (Courtesy White County Historical Museum.)

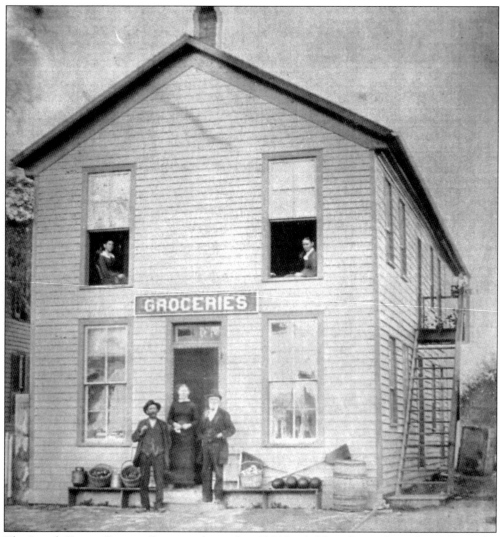

The Joseph Young Grocery Store was located at 234 North Main Street from the 1860s to the 1880s. It continued to be a grocery store into the 1900s but with different owners. Nowadays the Town and Country Inn is located at that address in a one-story building. (Courtesy White County Historical Museum.)

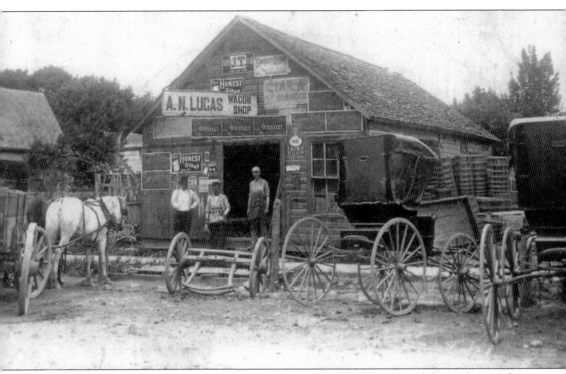

Wagon shops were a necessity in the horse-and-buggy days before automobiles took over the roads. The A. N. Lucas Wagon Shop prospered on Marion Street between Main and Illinois Streets in the early 1900s. A parking lot is now located where the wagon shop existed. (Courtesy White County Historical Museum.)

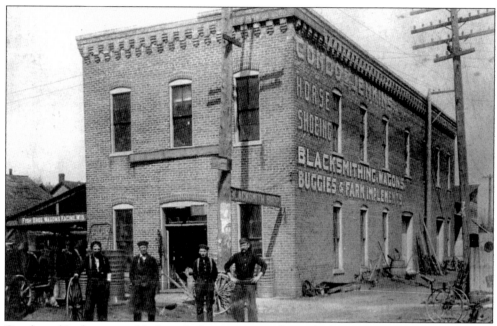

Condo and Jenkins was a blacksmith shop in Monticello in the late 1800s. This was an essential business before the horseless carriage came to town in the 1900s. It also sold buggies, farm implements, and wagons from Fish Brothers in Racine, Wisconsin. (Courtesy White County Historical Museum.)

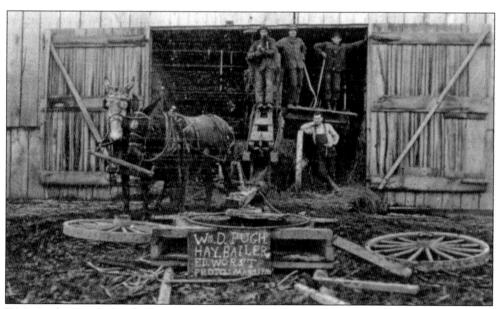

W. D. Pugh owned a hay-bailing company on Marion Street in the late 1800s. The location may have been on the northeast corner of Illinois and Marion Streets, which is now a parking lot. (Courtesy White County Historical Museum.)

Two

MONTICELLO IN THE 1900s

By 1900, the population of Monticello had grown to 2,107. It became a fifth-class city in 1909; the town board was replaced by a mayor and city council. The first mayor of Monticello was Thomas W. O'Connor, and W. J. Gridley was the first clerk-treasurer. The City Park was soon planned and begun on South Main Street. Some significant homes were also built in Monticello about this time, and many still stand today.

Electricity came to the city of Monticello in 1908, when the city entered into a contract with the Tippecanoe Electric Power Company to furnish street lighting and electric service to citizens. However, the company went bankrupt in 1912 and the Northern Indiana Utilities Company took over.

Many Monticello residents answered the call for troops to fight in World War I. Five Monticello residents lost their lives: George R. Arrick, Dr. Grant Goodwin, William Reece, Stewart G. Van Meter, and Bernard D. Wolf.

In the 1920s, among the companies operating in Monticello was A. J. Heinz, which had a pickle plant in town. Several Works Progress Administration projects were completed in the city in the 1930s. One project was Roosevelt High School and the Anheier Building, an activity hall at the City Park. Fire destroyed the Strand Theatre in January 1933, so the company opened the Lakes Theatre the next month in another building. Beer arrived back in White County in August 1933 after 25 years of being a dry county.

In the 1940s, Monticello residents found themselves volunteering to help the war effort, and several lost their lives in the effort. A decade later they were called to action in Korea and then Vietnam in the 1960s.

After the 1974 twister, the J. C. Reynolds Park was developed at the site of the old high school, which was damaged severely by the tornado. The park only lasted until 1986, when the land was sold to the library board, which built on the site in May 1992.

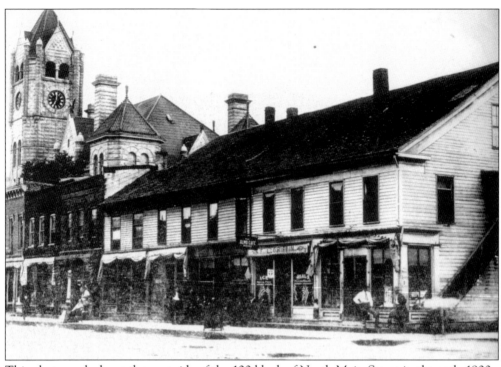

This photograph shows the west side of the 100 block of North Main Street in the early 1900s. The tall structure in the background is the White County Courthouse. T. L. Griffin had a store on the block, and the Almo Café was inside, as seen in the photograph below. It was quite fancy. Those buildings were replaced by one-story structures containing several stores. (Courtesy White County Historical Museum.)

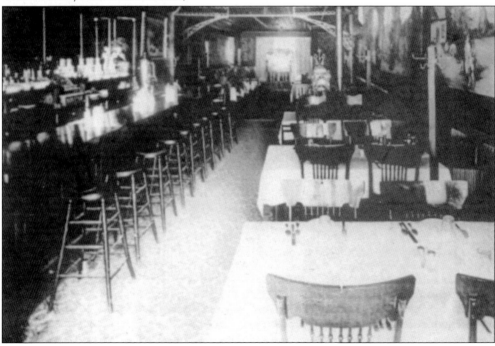

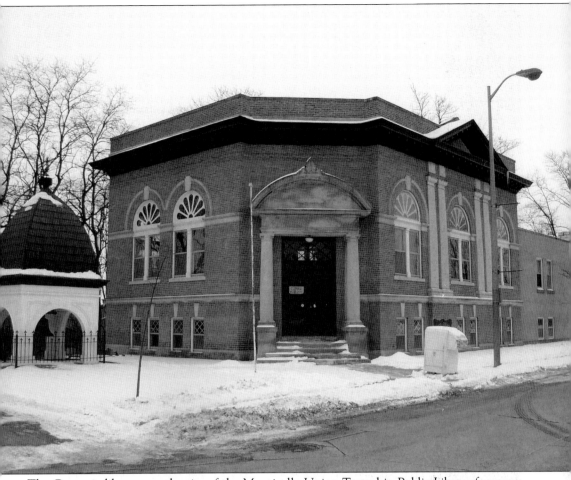

The Carnegie library was the site of the Monticello-Union Township Public Library for many years. The city library had a humble beginning. In 1903, the county commissioners provided the use of two rooms in the ground floor of the county courthouse for a library. Then a request was made to philanthropist Andrew Carnegie for a grant. The Scottish American steel entrepreneur offered a grant of $10,000 for a building and $1,000 a year to support the new library. After collecting donations of more than $1,000, founders decided on a property on the bluff in downtown Monticello to house the new library. The grant was accepted, and the building was constructed. To solve an overcrowding problem at the library in 1957, an addition was built thanks to a donation from Eva Casad. The addition was designed by Fort Wayne architect Charles E. Kendrick and built by a Mr. Levindouski of Lafayette. Now the building is the home of the White County Historical Museum.

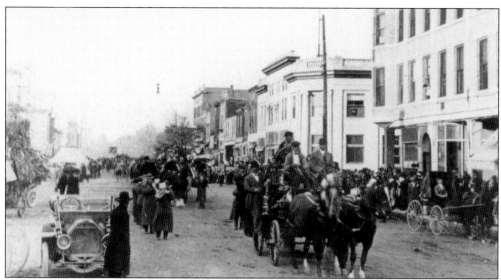

The Big Horse Show was held in 1911, and it featured a team of horses that was trained by firemen to dash to a certain spot down on Main Street when the fire bell sounded. The beautiful horses were adorned with ornamental trappings. (Courtesy City of Monticello.)

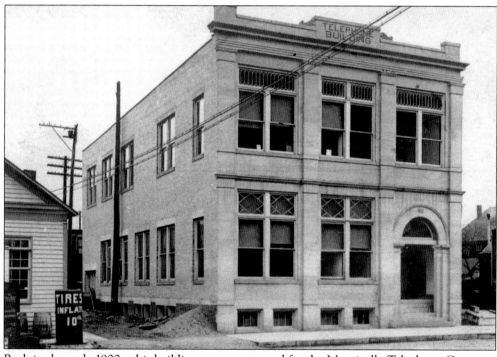

Back in the early 1900s, this building was constructed for the Monticello Telephone Company on Court Street. The company had 25,000 feet of underground and aerial wires. It also had a capacity of 2,000 local lines. The building was heavily damaged by the tornado and torn down. Court Street was also abandoned after the tornado. The telephone company today is run by Embarq, and its three-story building sits on Illinois Street. (Courtesy White County Historical Museum.)

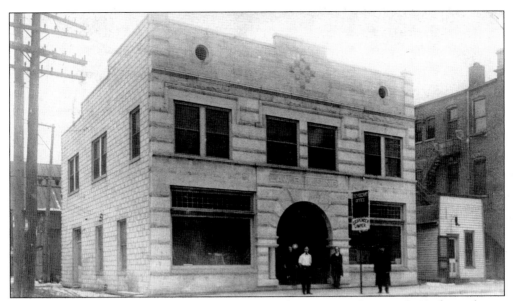

The Law Building was built in the early 1900s by Thomas W. O'Connor. It was located next to his home on East Broadway Street. The *White County Democrat* newspaper was located in the building. The first local lawyer was Albert S. White, who came to Monticello in 1837. Nowadays lawyers are located in various locations around the courthouse. (Courtesy White County Historical Museum.)

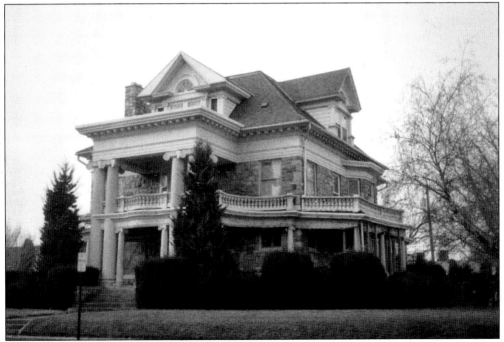

The Thomas W. O'Connor house was completed by the first mayor of Monticello in 1908. It took two years, two months, and nine days to build the classical revival house of hand-cut granite. The Democrat entertained many prominent members of the party, including Franklin D. Roosevelt before he was president. The house is now owned by Joyce Cottrell.

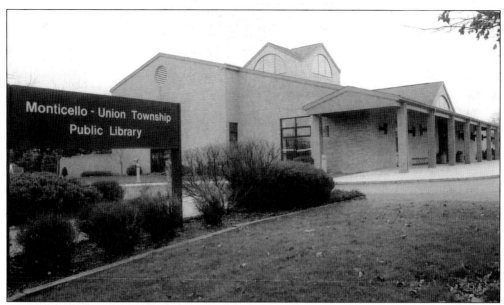

The Monticello-Union Township Public Library was first opened in May 1992 on the site of the old Lincoln Building. Today it serves the community with a collection of 61,780 books, CD audio books, CD-ROMs, DVDs, and videos. The library also offers many services, including reserving material, interlibrary loans, homebound services, internet access, and meeting rooms. The current director is Stewart Wells. The first librarian was Nora Gardner from 1905 to 1947.

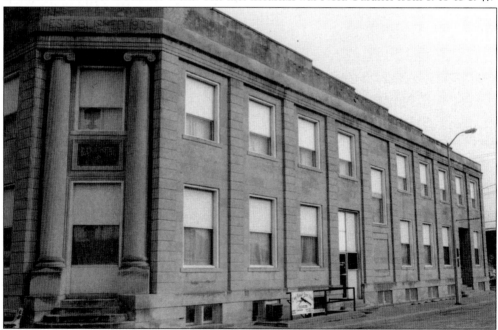

The Odd Fellows Building was constructed in 1905; however, Monticello Lodge No. 107 of the International Order of Odd Fellows (IOOF) no longer owns the building. Instead the building is owned by Blair and Griffith Attorneys. Another business located there is I'm Hair For You. The IOOF was first organized with a dozen members on January 30, 1852. It first met at the Commercial Block Building at the corner of Main and Washington Streets.

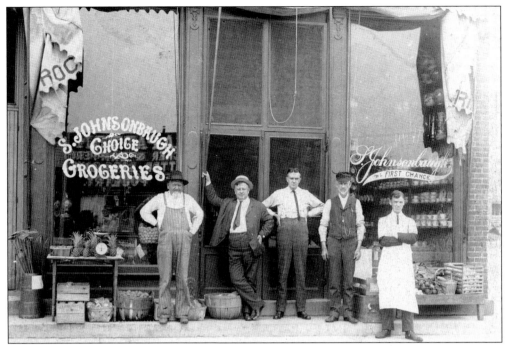

Sanford Johnsonbaugh was a grocer for more than 60 years at 234 North Main Street. From left to right are Ira Johnsonbaugh, a salesman, Earl Johnsonbaugh, Sanford, and store clerk George Todd. Sanford served on the Monticello Town Board in the 1890s and organized the White County Historical Society in 1911. The Golden Rule Creamery took over the location, as seen below in this 1925 photograph. Lero Hines (left) and Loyd Kilmer are pictured in front of the store, which paid cash for cream and eggs. The building is no longer there, and now the Town and Country Inn occupies the spot. (Courtesy White County Historical Museum.)

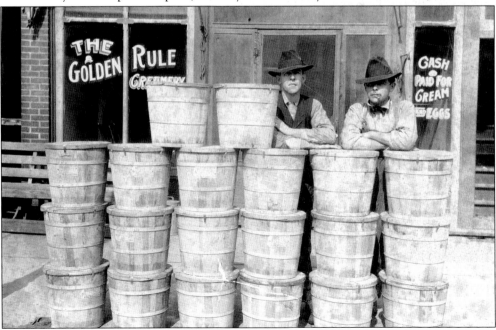

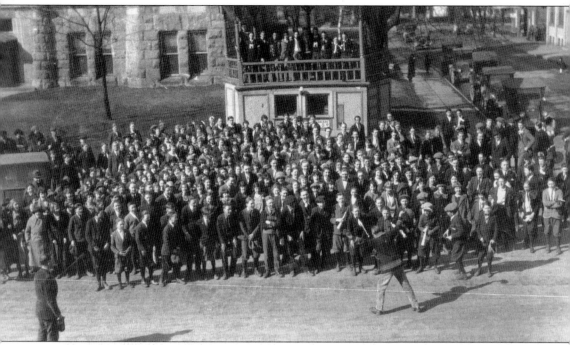

Hundreds gathered around the bandstand by the White County Courthouse on March 3, 1924. The bandstand was designed by noted architect Samuel Young and was built in 1896. It had a popcorn stand located beneath it. The bandstand was moved to the Monticello City Park and became shelter no. 6. Efforts to save it failed, and it was razed in 1987. (Courtesy White County Historical Museum.)

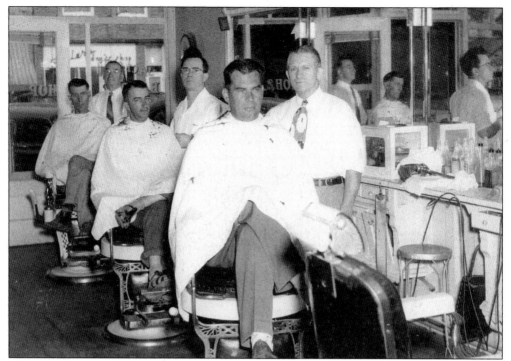

Boyd's Barber Shop was located on North Main Street in the early 1900s. In this picture the barbers are (from left to right) Victor Martin, Art Allison, and John Boyd. Today it is an empty lot between the La Mexicana Grocery Store and Wells Fargo Bank. (Courtesy White County Historical Museum.)

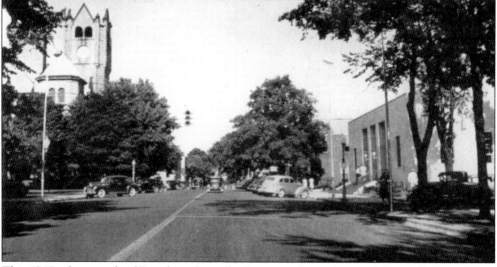

This 1940s photograph of Broadway Street looking east shows the new Monticello Post Office, which was constructed with Works Progress Administration funds. It opened in March 1940. The vernacular-designed building was conceived by Bradley and Bradley. James I. Barnes Construction Company of Logansport built the structure for $58,339. Inside, one wall in the lobby has a large painting of historic farming by Marguerite Zorach. The current postmaster is Dave Hawn. (Courtesy City of Monticello.)

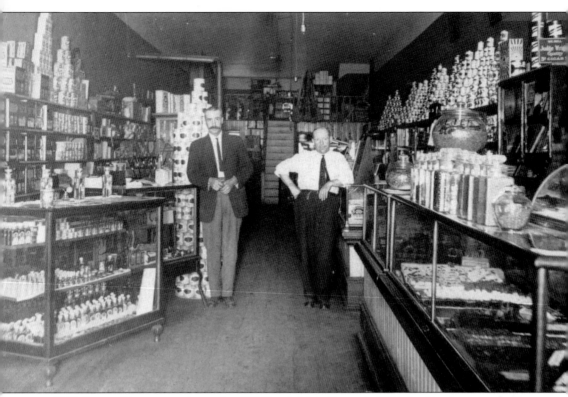

C. E. Barnes Grocery was located at 224 North Main Street in 1914. In this photograph, Barnes is on the left, and the other salesman is Frank Benjimen. Today the space is occupied by Main Street Computers and Office Supplies. (Courtesy White County Historical Museum.)

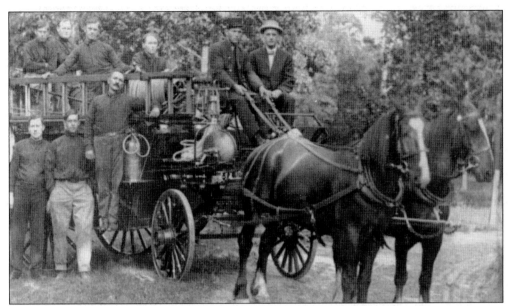

Monticello bought this horse cart, ladder, and bucket wagon for $1,979 in 1910. The American LaFrance combination chemical and horse wagon came with a new team of horses. Anthony A. Anheier, who would later become mayor, was the first fire chief. Other firefighters on the force included Charles Jackson, George Gilbert, George Lowe, Charles Smoker, Bob Heiron, Earl Day, Ed Davis, Walter Simon, Wil Bott, and Homer Turner. (Courtesy Monticello Fire Department.)

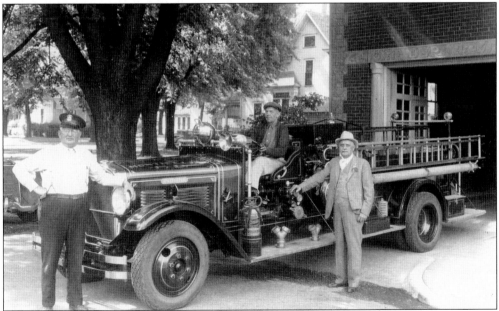

In this photograph from the 1930s, police chief Charles Wright stands in front of the fire engine with Bud Ireland, fire chief, at the helm. Also in the photograph is Mayor Anthony A. Anheier, who served as mayor from 1934 through 1937. City hall contained all three departments in the 1930s: fire department on the left, police station on the right, and major's office upstairs. (Courtesy White County Historical Museum.)

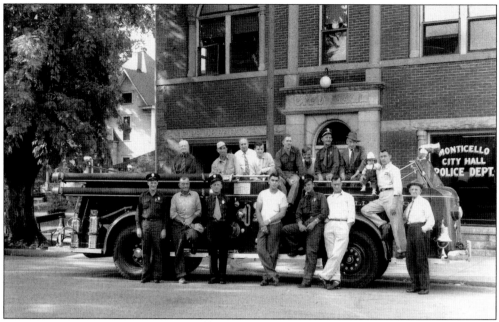

Monticello firefighters lined up for this photograph in 1947 in front of their $9,455.29 fire truck. (Courtesy White County Historical Museum.)

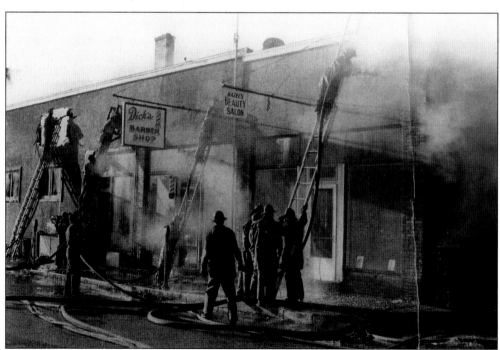

In the late 1940s, firefighters had to battle a blaze at Dick's Barber Shop and Hazel's Beauty Salon at 845 North Main Street. The Admiral gas station is now located at that corner. One of the worst blazes in Monticello's history was at the old RCA plant in September 2005, involving more than 200 firefighters and fire companies from nine communities. (Courtesy White County Historical Museum.)

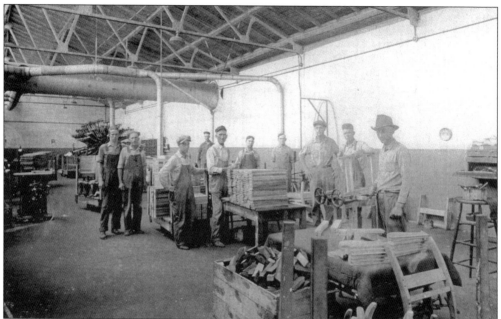

This photograph from the 1930s shows workers of the Rider Furniture Company. The plant was originally owned by the Monticello Cabinet Company. The photograph shows the outside of the plant after it was purchased by RCA to make cabinets for televisions. The cabinets were sent by rail to the RCA television plant in Bloomington. The plant was the largest in the city and went strong until 1974, when 200 employees were laid off as the demand for cabinet televisions decreased. RCA later laid off another 400. Then RCA closed the plant in October 1982. It was purchased a couple of years later by Jordan Manufacturing, a furniture company. A huge fire in September 2005 destroyed much of the building. (Courtesy White County Historical Museum.)

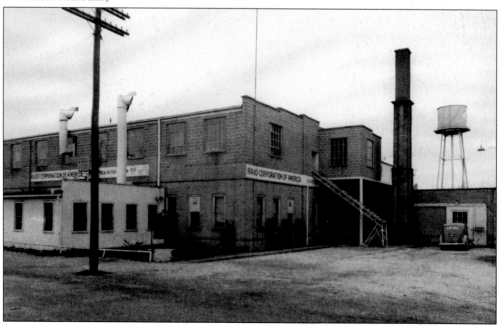

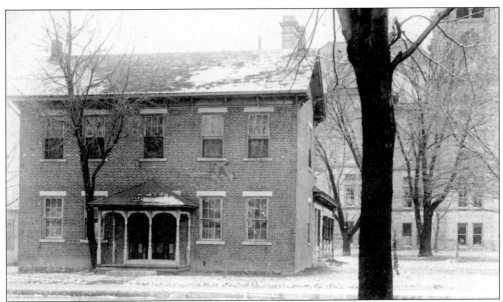

The White County Jail was located on the same block as the courthouse back when this photograph was taken in 1918. It was built in 1865 by Ralph Dixon of Logansport. The sheriff's living quarters were located in the front of the building. In 1918, J. C. Williams was the sheriff until he died in office and his wife, Etta, was appointed to serve out is term. A 1919 grand jury condemned the jail and ordered it razed. It was removed in 1922. (Courtesy White County Historical Museum.)

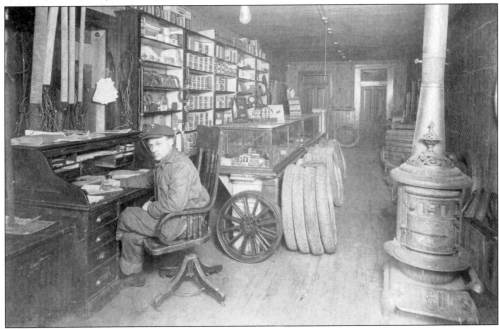

This photograph from the 1920s shows the inside of Mummert Brothers Gas Station, which was located at 228 West Broadway Street behind the First Presbyterian Chuch. Roscoe Mummert relaxes at the desk. He was part owner in the station. The Mummerts later opened a gas station down the street that is now the Garden Station. (Courtesy Bud Mummert.)

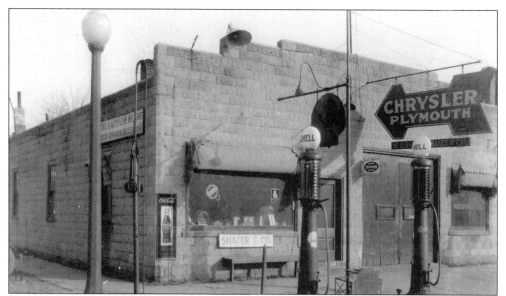

Boyd "Pig" Shafer's garage started business in 1927 at 218 North Main Street before moving to 228 West Broadway (a station owned by the Mummerts) in the 1930s. Shafer later opened a Chrysler/Plymouth dealership at 306 North Main Street. The photograph below shows the store at Christmastime with Santa Claus on his sleigh in the front window. (Courtesy White County Historical Museum.)

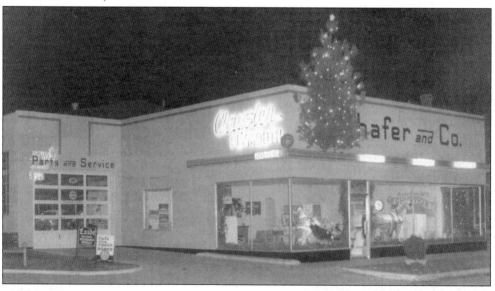

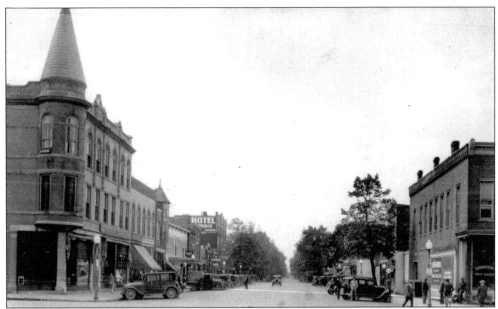

The O'Connor Building on the left side of this south view of Main Street was built in 1901. It had the distinction of being the first building in Monticello to have an electric sign in town on November 21, 1901. The building was owned by Thomas W. O'Connor, who would become the first mayor of Monticello. Located on the corner of Broadway and Main Streets, the building had a copper tower that later turned green from the weather. (Courtesy City of Monticello.)

The Monticello Street Department worked out of this Quonset hut before its current building was constructed in 2003. The six city employees enjoy the new building in comparison to the old hut. Besides the 1974 tornado, the street department had a tough time cleaning up after the blizzard of 1978. (Courtesy Monticello Street Department.)

The Knights of Columbus used this building on West Broadway Street after it first formed on July 17, 1977. Then in 1990, it purchased its present headquarters on Illinois Street at an auction. Jim Gill is the present grand knight of the charitable organization. The organization holds bingo every Sunday night, and most proceeds are donated to several charities, such as the Salvation Army. In 2006, it gave away $31,000.

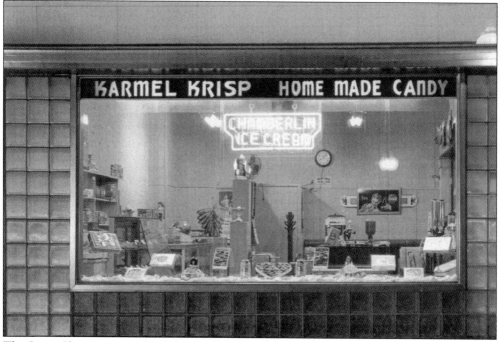

The Sweet Shop was owned by Florence Fell Wood from the mid-1930s to the mid-1950s. It was located on the south side of the courthouse square at 109 West Broadway. That space is now occupied by Roth Jewelers. (Courtesy White County Historical Museum.)

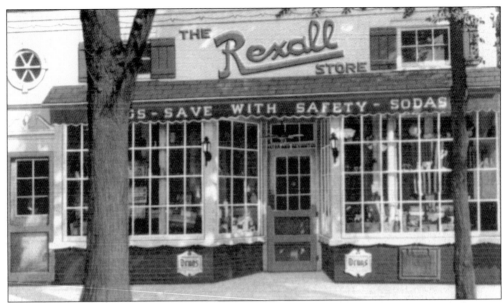

The Rexall drugstore on North Main Street served Monticello for many years. The owners at the time of this postcard were Alter and Revington. The last owner of C. D. Rexall Pharmacy was Don Holverson. For the last 10 years, the store has been the Main Street Mall, a store full of antiques owned by Jim Haworth, who grew up in Monticello. (Courtesy White County Historical Museum.)

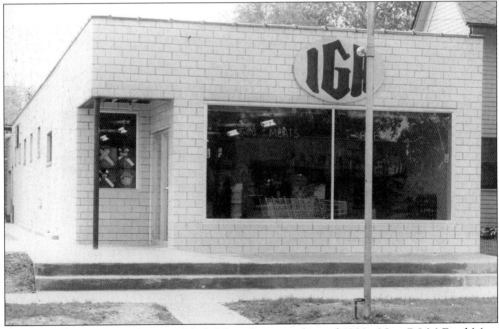

An IGA store was located at 701 South Main Street in the mid-1900s. Now R&M Food Mart operates from the same location. Another old grocery store favorite about the same time was the A&P store on Main Street. Kroger also had a store in downtown Monticello at one time. (Courtesy White County Historical Museum.)

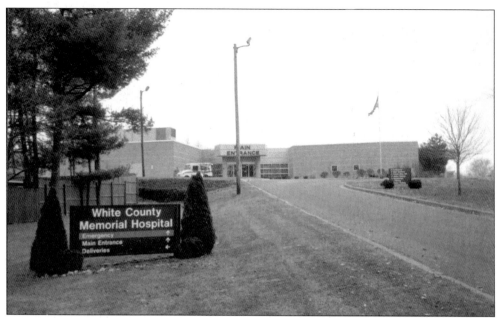

Interest in building a hospital began in 1926, but it took another 30 years before White County Memorial Hospital was built as a 20-bed facility on land donated by the O'Connor estate. Five physicians and a surgeon were on staff when it first opened. It has since gone through many changes and now has 59 beds. The next change will be even more drastic as a new hospital is being built on South Sixth Street

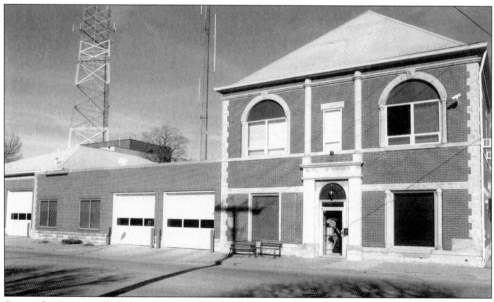

Soon after Monticello became a city, the city hall structure on the right was built in 1904. The Romanesque building was designed by Samuel Young. The fire department, police department, clerk-treasurer, and mayor were located in the building on the right for many years before moving to the municipal building on Main Street. The addition on the left for the fire trucks was made in 1994.

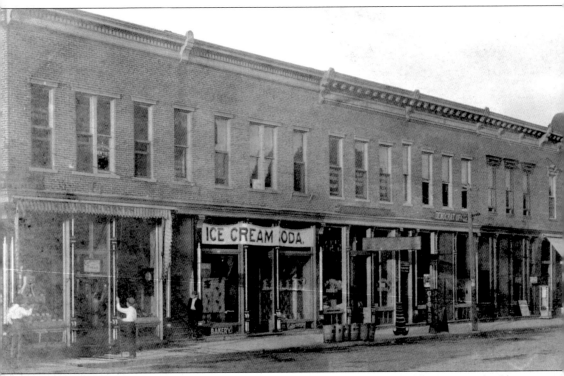

Back in the 1920s, Broadway Street south of the courthouse was lined with two-story buildings. Davis and Son Grocery Store sat on the corner with a bakery next door and J. W. Meiser farther down. Those buildings were devastated by the tornado and removed. They were replaced with one-story buildings. Today the stores on this stretch of street are Congressman Steve Buyer's office, Monticello Custom Frame and Gallery, Cox and Company, Jerry's Photography, Robert B. Christopher, Roth Jewelers, and White County Abstract. (Courtesy White County Historical Museum.)

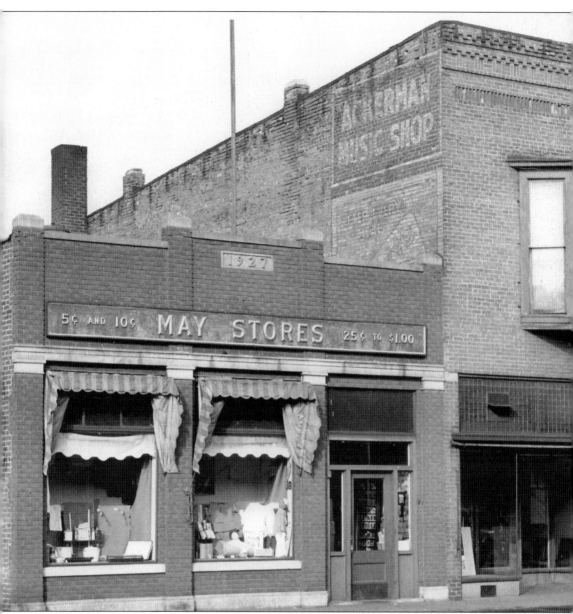

The May Stores was a five-and-dime store located in a 1927 building on the corner of Harrison and Main Streets in the 1940s. Next door was the Akerman Music Shop. The buildings were damaged by the 1974 tornado and were taken down. Today the spot is occupied by R. W. Gross and Associates Land Surveyors and SugarDog.com. (Courtesy White County Historical Museum.)

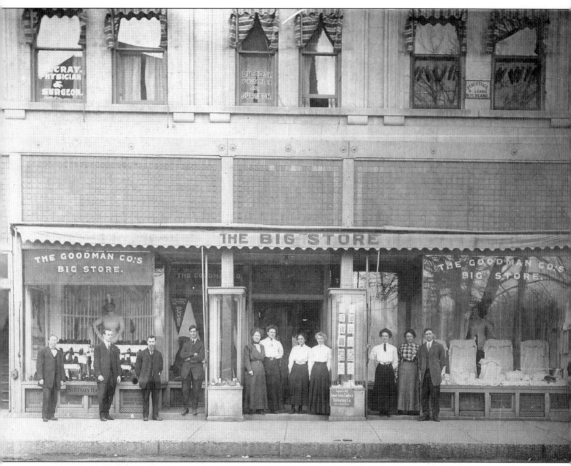

This photograph from the early 1900s shows Goodman's Big Store on Main Street across the street from the courthouse. The store opened in 1902. Dr. Cray had an office upstairs. Goodman's lasted until the 1950s, when it was sold to Jerry Alexander, who changed the name of the store to Miller's Department Store. The name was changed to Alex's 11 years ago. Jerry's son John now manages the store. (Courtesy White County Historical Museum.)

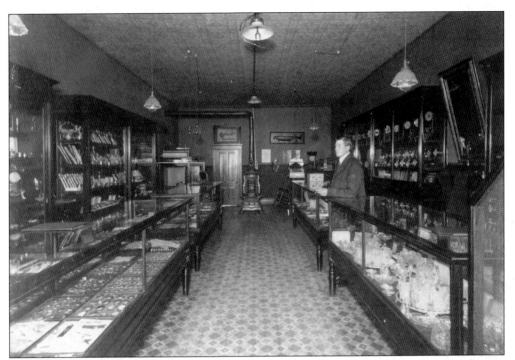

This 1912 photograph shows owner Sam Thompson Sr. inside his store, Thompson Jewelry. He later turned the store at 113 South Main Street over to his son. Then the store was purchased by the Roths (Vincent and Francis), below in 1946. The store was moved to Broadway Street after the tornado. It is now run by Willie Roth, a third-generation owner. (Courtesy Roth Jewelers.)

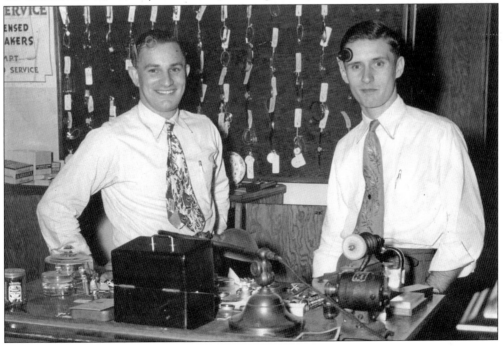

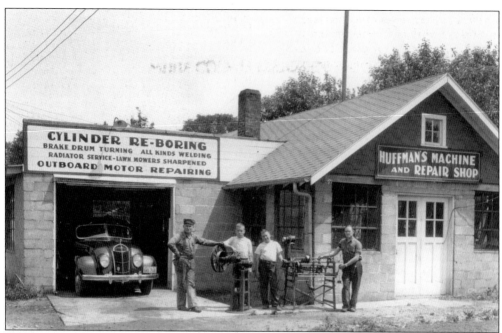

Huffman's Machine and Repair Shop was located at 318 South Illinois Street in the 1930s. The garage has since been turned into a residence. (Courtesy White County Historical Museum.)

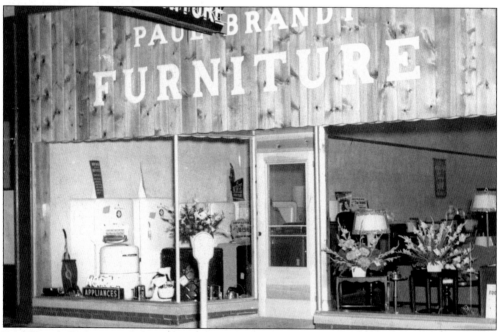

Paul Brandt Furniture was located at 210 North Main Street in 1951 when this photograph was taken. Dekker Furniture took over the space in 1974 just before the tornado. The store lasted until 2006, when it went out of business after 33 years. Louis Gustavel operated a furniture store there in the 1890s. The Tiger Store was the furniture store of the 1920s. (Courtesy White County Historical Museum.)

The first modern water tower was built in 1958 at Fourth and Foster Streets. It holds 500,000 gallons of water. The water department added two more water towers in 1981 on West Shafer Drive, and Sixth Street and Gordon Road. They replaced the old standpipe.

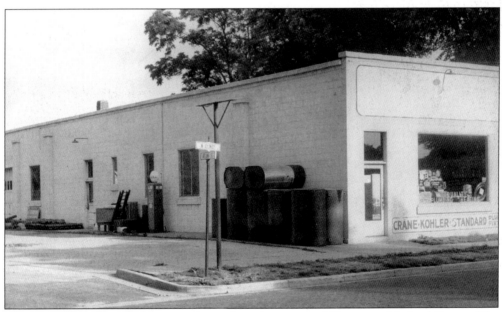

The Hatton Plumbing building was located on the corner of Illinois and Ireland Streets. The company was around in the mid-1900s. That section of Ireland Street was renamed Short Street. The building is now occupied by the Union Township trustee, Bernie Cook. (Courtesy White County Historical Museum.)

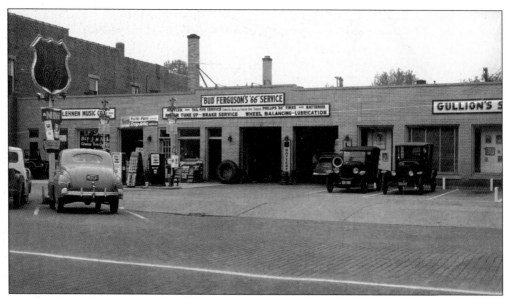

O. D. "Bud" Ferguson ran a "66" Service on the west side of South Main Street from 1954 to 1974. The Lehnen Music Company and Guillion's Studio had stores on either side of the gas station. After the 1974 tornado, the building was renovated and Ferguson turned his attention to a 28-year career with the county council. Stores there today are Hoover and Associates Financial Services, Dr. Peter Dyer, chiropractor, and Kelley's Interiors. (Courtesy White County.)

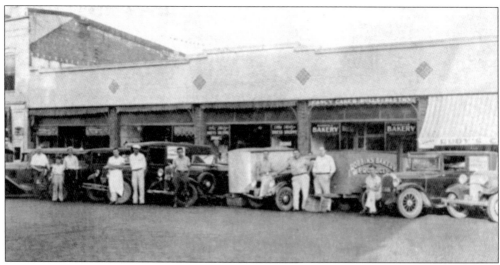

The Robbins Bakery was located at North Main Street back in the 1930s when this photograph was taken. Today a number of stores are located there, including WMRS Radio Station, Sonn Hearing Care Professionals, First Horizon Home Loans, and Martin's Carpet Service. (Courtesy White County Historical Museum.)

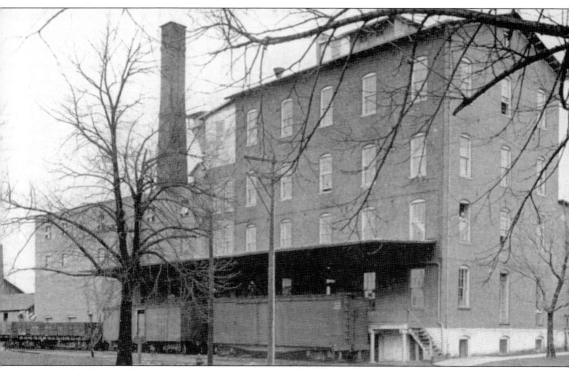

The Loughry Brothers Grain and Milling Company at 402 North Main Street operated in Monticello from 1872 until after World War II. It took over a mill that was first built in 1850. Now the Olde Mill Apartment complex is located there. (Courtesy White County Historical Museum.)

This is how the Anheier Building looked just before it was completely renovated in 2002 for around $600,000. It was constructed in the 1930s with funds from the Works Progress Administration and named after Mayor Anthony A. Anheier. The building was used temporarily by the county after the 1974 tornado. Now it houses the parks department office and Monticello Head Start. (Courtesy Monticello Parks Department.)

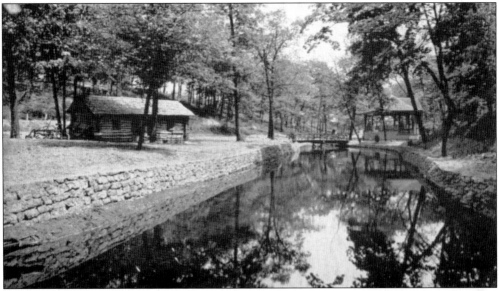

The City Park was started after Monticello became a city in 1909. This postcard shows a log cabin at the park that was built in 1912 and believed to be there up until the 1930s. The cabin was used by the Girl Scouts. The stream was once used as a canal for a fish hatchery. (Courtesy City of Monticello.)

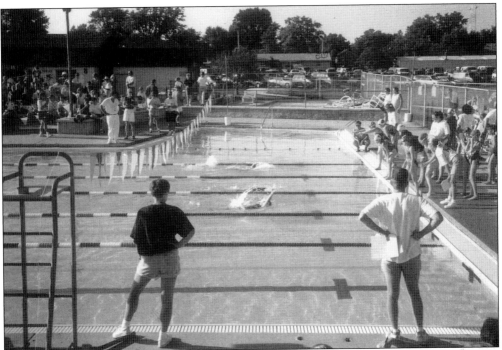

People enjoy the city pool every summer, as seen in this photograph. The pool was constructed in 1969, and 643 families joined for $33. It was damaged by the 1974 tornado. The pool ran into financial difficulties, and the city took over the pool in 1983. (Courtesy Monticello Parks Department.)

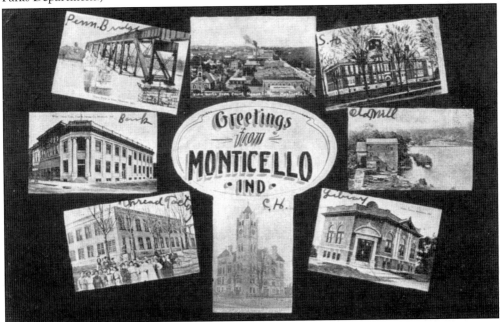

This old postcard shows many of the older buildings and scenes that existed in Monticello in the early 1900s. In fact, the scenes and buildings in this postcard were used as other postcards. Monticello postcards first came about in the early 1900s. (Courtesy City of Monticello.)

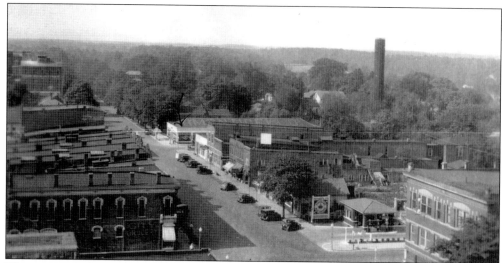

This postcard shows Monticello looking north down Main Street from the top of the old courthouse. The standpipe stands tall in the upper right side. On the northeast corner of Main Street and Washington Street is a Standard station. BP owns the station today. Across the street from the station is a three-story building that was reduced to two stories by the 1974 tornado. (Courtesy City of Monticello.)

This old concession stand is what is left of the Monticello Speedway, which opened in July 1950 to 7,800 fans. The clay track cost $200,000 to build and was located at Gordon and Airport Roads, outside the city limits at the time. It could seat more than 10,724 fans and featured stock cars and midgets. General admission was 83¢. In 1961, it was sold to the Monticello Christian Church.

Three

THE TORNADO

Monticello was much like any county seat in Indiana. It had an old county courthouse surrounded by old buildings with a lot of history. That history changed on April 3, 1974, in a matter of a few minutes. The town was ripped apart by a tornado that killed eight and caused an estimated $100 million in damage.

The tornado was born in a field two miles west of Otterbein at 4:50 p.m. The tornado leveled some farmhouses on its way toward White County. By the time it reached the southwest part of Monticello, the twister had reached the F-4 level, up to 260 miles an hour! The funnel cloud took aim at Twin Lakes High School and Roosevelt Junior High and badly damaged both. Then it leveled houses on Harrison Street. National Homes were blown apart. "It looked like watching clothes in a dryer," recalled Ted Baer.

The twister took aim at the county courthouse and ripped its top apart. Other buildings in downtown Monticello were badly damaged. The storm defied the experts and dipped almost 60 feet down the bluff toward the Tippecanoe River and devastated Bryan Manufacturing. Then the tornado knocked off huge bridge sections of the Penn-Central Bridge. Just south of that bridge, the strong winds swept a van into the river below and five people from Fort Wayne were no more. One of the passengers, Karen Stotts, survived the fall. She swam to safety.

The Salvation Army took up residence in the Monticello United Methodist Church to serve meals for weeks to the tornado-torn residents. It also served as a junior high school until the school could get into its own building again. Other students were sent to some of the other churches in town.

Twin Lakes High School suffered so much damage that students had to use portables for more than a year. "We made do," said Larry Crabb, a former teacher. "The kids did a great job of adjusting." It took five years for the city to recover. Federal funds of $7 million were administered by the Monticello Redevelopment Commission as part of Project Windswept.

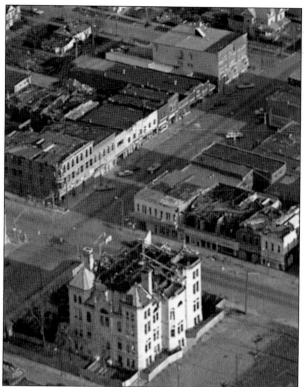

This aerial photograph shows the damage to the White County Courthouse and to the buildings across the street along Broadway Street. More than 100 buildings downtown were damaged by the storm. As a result of the tornado, the city got a new courthouse, storm sewer system, sanitary treatment plant, sidewalks, curbs, streets, lights, parking lots, and shopping facilities. The traffic pattern was also changed in downtown. (Courtesy Jerry's Photography.)

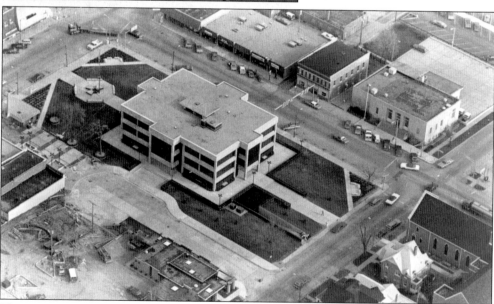

The present county courthouse was dedicated on August 27, 1976. The architects of the building were Longardner and Associates. Black Casteel Construction Corporation of South Bend took 17 months to construct the brick-and-concrete structure at $2.4 million. The three-story building has 45,280 square feet of space. The focal point of the atrium is a 32-foot mobile of copper-coated steel wire and brass strips mottled in patina finish. (Courtesy White County Historical Museum.)

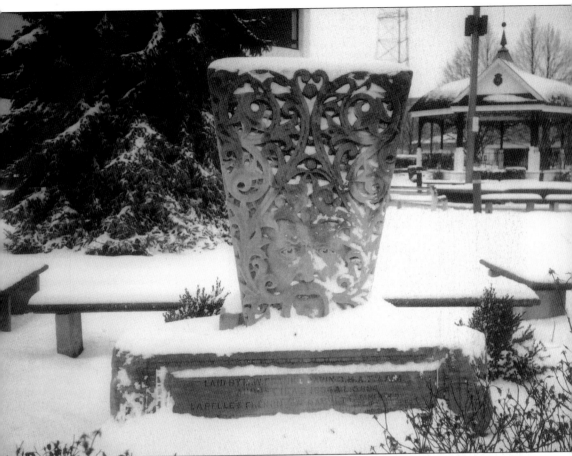

The Old Man in the Stone was first laid in the old courthouse on August 16, 1894, by Frank E. Gavin. It was the keystone in the center arch. Labelle and French was the architect of the courthouse that was destroyed by the tornado. *The Old Man* was recovered and now sits as a monument on the grounds of the new courthouse. Bill Altheer, county engineer, designed the setting. Doug Roberts was the White County highway superintendent at the time, and he and his men put the stone there in 1980.

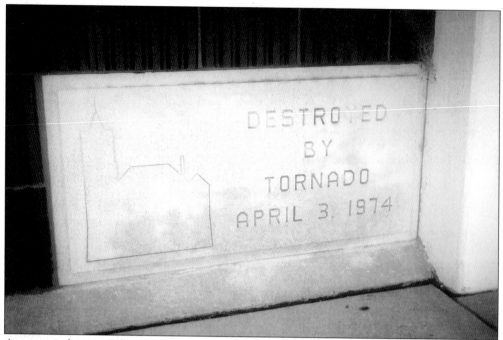

A stone on the new White County Courthouse commemorates the old courthouse destroyed by the tornado. Many citizens loved the architecture of the old courthouse and miss it, but the new courthouse is more functional than the old one was.

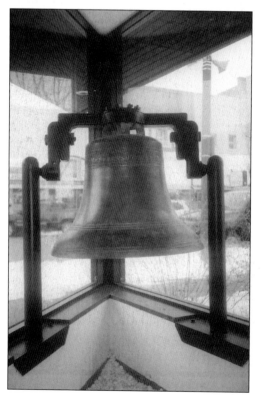

The bell from the courthouse that was destroyed by the tornado now sits in the chamber of commerce office. The bell was cast in a New York foundry and traveled over inland rivers and canals to Lockport and then was hauled by wagon to Monticello in 1852. It was placed in the second courthouse, a brick building, which was replaced by the third courthouse that was destroyed.

Homes along several streets like this one were devastated by the tornado. Trees were torn apart and some fell on homes. This was one of the hardest residential districts hit. The National Homes district was also devastated. Many homes had to be rebuilt, and many others had to be repaired. (Courtesy White County Historical Museum.)

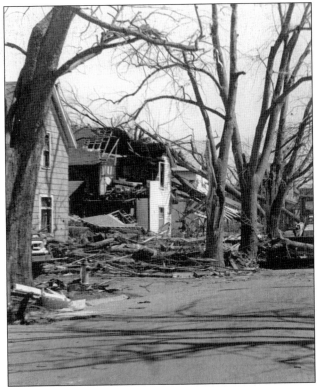

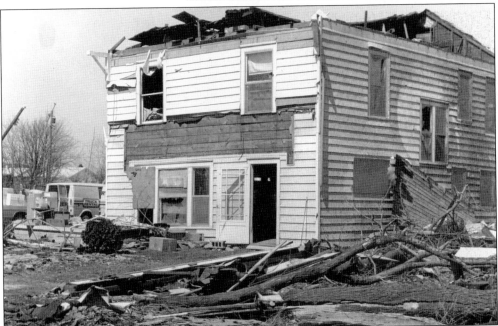

This is another home shattered by the tornado. Electricity was knocked out for a week. Destruction like this led Paul Manley to tell his wife, "The whole town's gone! The whole town's gone!" Not quite, but the tornado did leave a large path of destruction through Monticello that reminded veterans of wars they had fought. (Courtesy White County Historical Museum.)

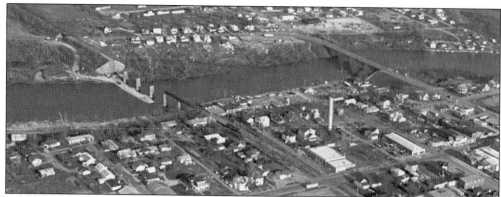

This aerial view shows the huge bridge sections that were knocked off the Pennsylvania Railroad bridge that crosses Lake Freeman. It was knocked out for a while after the tornado. The bridge was built in 1927 at a cost of $300,000. Damages were more than $500,000. (Courtesy Jerry's Photography.)

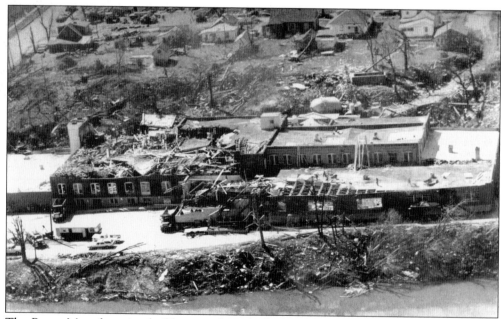

The Bryan Manufacturing building was heavily damaged by the 1974 twister. The company later went out of business in 1980. Today the building is used as a warehouse and several other purposes. Many businesses were damaged by the twister, including Diener's Supply Warehouse, Sixbey's Hardware, United Telephone Company, Teegarden-McGraw Ford, Hubbard's Chevrolet-Cadillac, Texaco, First National Bank, Kestle's Shoe Repair, Greenlee Electric, B&R Furniture, Barr Department Store, and so on. (Courtesy White County Historical Museum.)

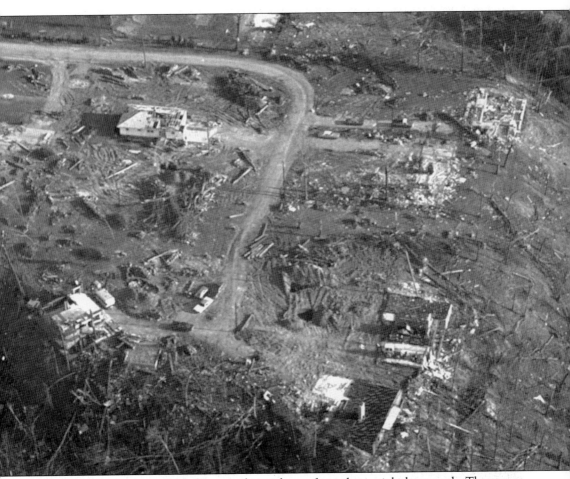

Rural areas were not spared by the tornado, as shown from this aerial photograph. The storm continued on its way across the state, damaging property and killing others in Rochester, Talma, and Leesburg before ending near Oliver Lake in Lagrange County. In all, 19 people lost their lives from that one storm and eight of those were in Monticello. (Courtesy Jerry's Photography.)

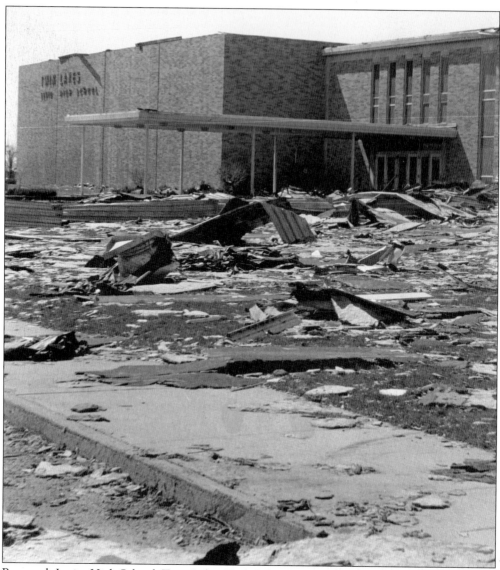

Roosevelt Junior High School, Twin Lakes High School, and Meadowlawn Elementary were all damaged by the storm, sending students to area churches or portable classrooms until their own schools could be repaired. The high school football field was also damaged as the twister took down some of the lights and trees in the area. (Courtesy White County Historical Museum.)

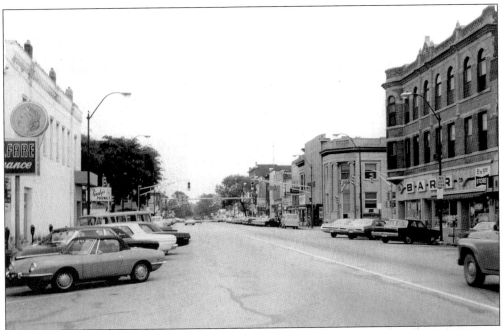

This view of Main Street looking north shows Hivley's Pharmacy on the left and the Barr Department Store on the right in the old O'Connor Building. Both buildings suffered damage by the 1974 tornado and were taken down. Today Pampel and Associates is located where Barr used to be and Congressman Steve Buyer's office is where Hivley's was located. (Courtesy White County Historical Museum.)

The corner of Broadway and Main Streets looked quite a bit different after the rebuilding that occurred after the tornado. The Hallmark store was located on the corner. It has since moved farther down Main Street in the same complex. Today Pampel and Associates is located on the corner. Twin Lakes Theater is located there as well. (Courtesy White County Historical Museum.)

This photograph was taken sometime after the 1974 tornado and shows the office of the *Monticello Herald-Tribune* in a building with the financial center. Hivley's Pharmacy is on the corner with Broadway. Today the newspaper has the whole building, and the Twin Lakes Financial Services is next door. Hivley's drugstore is no more. The *Monticello Herald* first came about on February 2, 1862. (Courtesy White County Historical Museum.)

After the tornado, the 200 block of North Main Street on the east side contained (from left to right) Jack's Liquor Store, Yours and Mine Tavern, Rickett's Liquor Store, McLaughlin Attorney, and Griffin's. Rickett's is still there today. Other stores there today are Today's Head Lines, Kinser's Bakery, Janet's Intown Lounge, and Abe's Pizza. (Courtesy White County Historical Museum.)

Before the 1974 tornado hit, the west 200 block of North Main Street contained Gambles, the Wagon Wheel Restaurant, Maiben's Laundry, and a café. Those buildings were taken down after the tornado. The photograph below was taken shortly after the tornado and shows a new building was constructed at the corner of Main and Washington Streets. At first, it was called a financial center; a flooring store was located on the corner. Today the complex has several businesses: James L. Milligan Land Surveyor, American Quality Systems, Creative Color and Cut, and Manpower. The Dekker Furniture Store next door suffered some damage from the tornado but survived. It went out of business in 2006. (Right, Jan Lindborg; below, White County Historical Museum.)

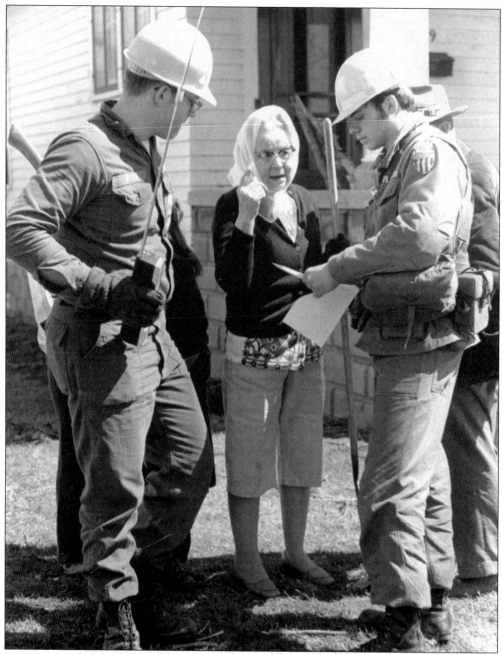

An unidentified woman speaks to a couple of utility workers after the tornado. Power was out for a week after the storm. It snowed the day after the storm, and many people suffered from the cold with no heat or power. (Courtesy White County Historical Museum.)

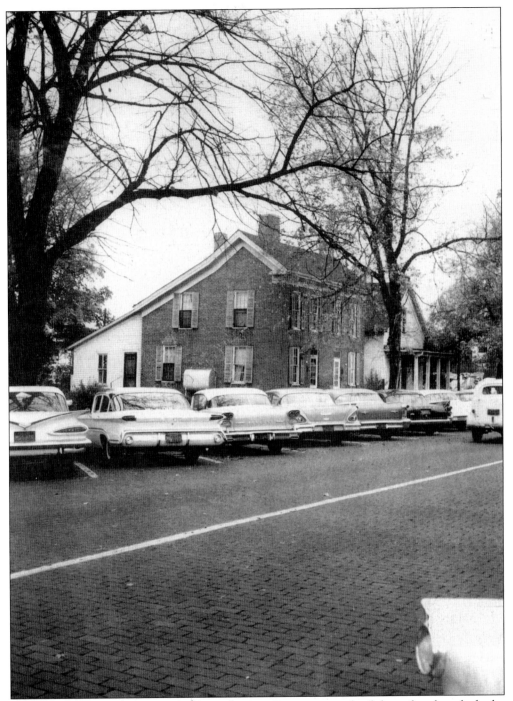

Before the tornado, the west side of North Main Street just south of the railroad tracks had a couple of houses; the brick house belonged to Russell Jenkins, and the frame house belonged to Bertha Peet. After the tornado, McDonald's built a restaurant there in 1978 where these two houses once sat. (Photograph by Jan Lindborg.)

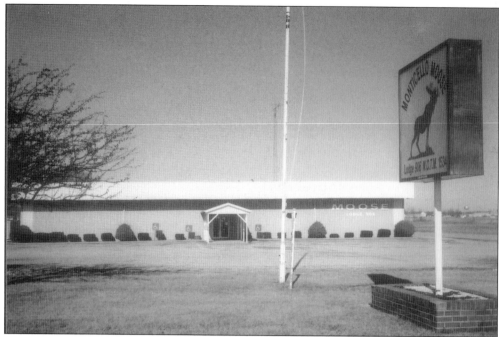

The Moose lodge on Gordon Road was destroyed by the 1974 tornado, and this new building was constructed using the old one's foundation. Moose members below came together on June 2, 1963, when the lodge was first chartered. Then their original building was constructed in 1973. The Moose lodge supports the community food pantry, soccer leagues, and other youth groups. Bingo is held once a month at the building. Today the Moose have about 300 members with senior citizens' and women's groups. The leader of the Moose here is Gov. Eric Marzke. (Courtesy Moose Lodge 906.)

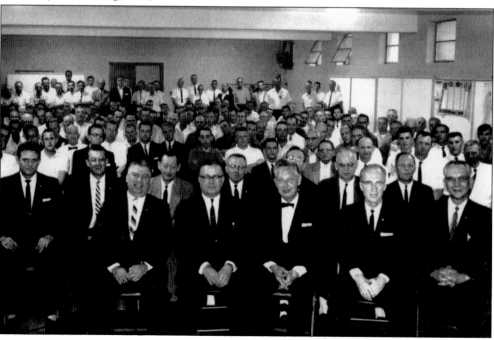

Four

MONTICELLO SCHOOLS AND CHURCHES

When Monticello first began, a circuit rider named Stalker was the first to spread the word of the gospel in Monticello in 1834. Then the Presbyterian and Baptist religions began holding services in the first schoolhouse in 1835. The Methodists first organized in Monticello in 1836 when a handful of worshippers met at Orwig's Tavern with Fr. Hackaliah Vrdenburg, a circuit preacher.

The first school was built at the corner of Harrison and Main Streets in 1835. The 20-foot-by-30-foot frame schoolhouse had iron latches and hinges for the door, and sash and glass for the windows, which were put up high so students would not knock them out. Teachers had trouble disciplining the children, and one teacher ended up in jail after "cowhiding" and blooding one of his male pupils.

The first resident minister was Alexander Williamson, who was Presbyterian. He lived in Monticello and delivered a sermon there before going out to the country to deliver more sermons.

Rev. John Stocker organized the First Church, which completed the first church building in 1846. The First Church and Second Church unified in 1867 but later sold the church to the Baptists, who moved it to the east side of Bluff Street south of Jefferson Street. It was later torn down.

The Christians first started meeting in Monticello in 1854, but they had no church until they purchased an old one from the Methodists in 1887. The Catholics built a small church in town in the 1880s, but it did not last. They did not return until the 1950s and are here to stay. Some other religions have come and gone and come again over the history of the city.

By 1948, only four churches were listed in the telephone book in Monticello: Christian Church, United Methodist Church, Presbyterian Church, and Wesleyan Methodist Church. A decade later, that number had doubled.

The Twin Lakes School Corporation consolidated in 1963, combining Monticello and Union Township. Today five schools in Monticello—Twin Lakes High School, Roosevelt Junior High School, Meadowlawn Elementary, Oaklawn Elementary, and Woodlawn Elementary—serve about 2,200 students.

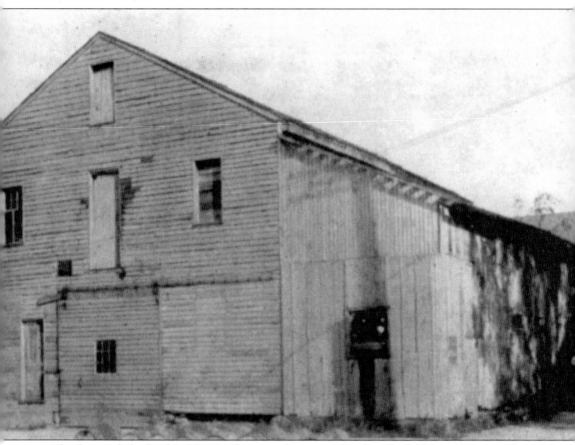

The first graded school in Monticello came about in 1858 when Prof. George Bowman opened the facility in an old warehouse. It was located on Harrison Street behind the Hotel Forbis. The Warehouse Academy, as it was called, only lasted a few years as Bowman was mustered into Union service and went off to the Civil War. He was wounded in the war and discharged. He returned to Delphi and became a principal. He later became the county superintendent. The old school was turned into a horse stable. (Courtesy White County Historical Museum.)

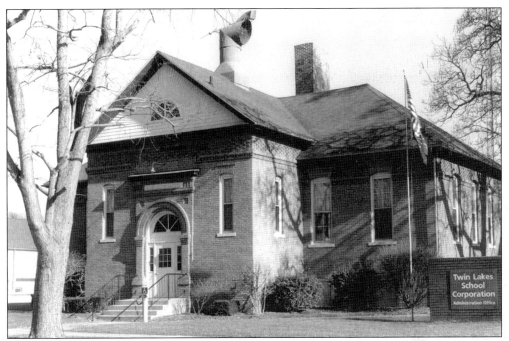

The South Grade School on South Main Street was built in 1892 to provide education to the elementary school children of the city. It cost $10,000 to build the structure. The all-brick building of Romanesque Revival design now houses the administrative offices of the Twin Lakes School Corporation. The building is on the National Register of Historic Places.

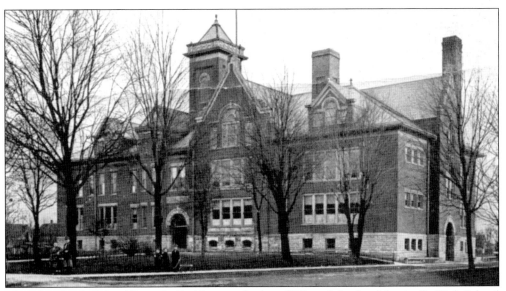

The West Grade School/Lincoln Building was built in 1870, and the first Monticello High School graduation occurred in 1881. Named after Pres. Abraham Lincoln, the school was damaged by a fire in 1905, and the interior had to be remodeled. The high school moved to the Roosevelt Building in 1939, and it became a junior high school. It was torn down after the 1974 tornado. (Photograph by Jan Lindborg.)

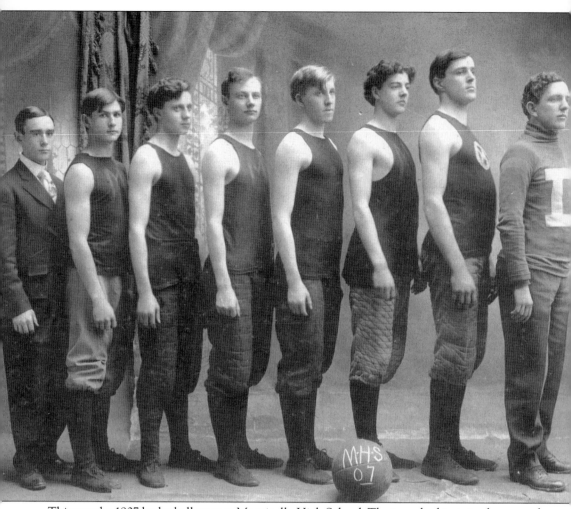

This was the 1907 basketball team at Monticello High School. The team had just six players, and they are, from left to right, King Rawlins, Karp Stockton, Tom Bushnell, Ozro Lucas, William Barnett, and an unidentified player. The name of the coach is unknown. The team played just three games during the season. It won handily against Wabash and Rensselaer. Its only loss came to a stronger Lafayette team. (Courtesy White County Historical Museum.)

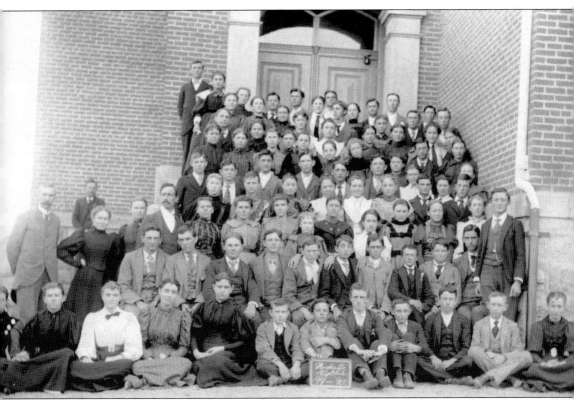

Students of Monticello High School posed for this photograph in 1895 on the steps of the Lincoln Building. The graduating class of the school contained 15 students. The superintendent of Monticello schools at the time was John W. Hamilton. The high school suffered a large interior fire in August 1905, delaying school by a week. (Courtesy White County Historical Museum.)

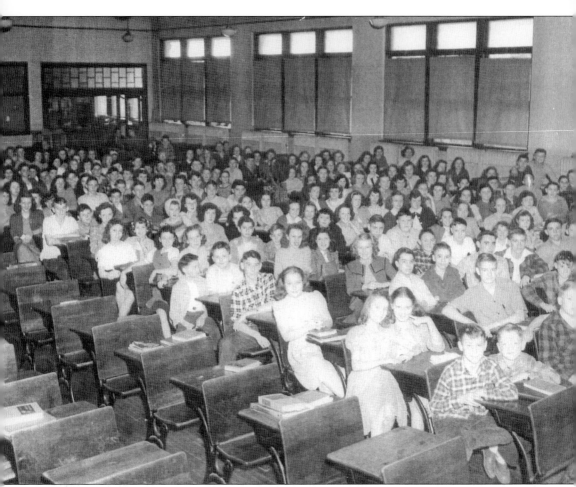

Albert Douglass snapped this photograph of the entire Lincoln Junior High School in 1947. The school contained 217 students. The principal at the time was James W. Dyer. Lincoln was vacated in May 1971 after Twin Lakes High School was built and Roosevelt Junior High School was renovated. It was torn down after being damaged by the tornado. (Courtesy White County Historical Museum.)

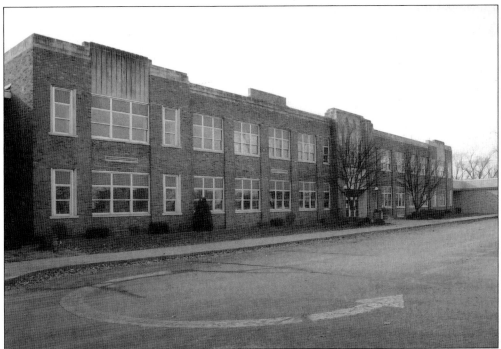

Monticello–Union Township had Roosevelt High School built in 1938 at a cost of $124,992 by A. I. Longacre. It was named after Pres. Franklin D. Roosevelt because it was built with Works Progress Administration funds. Architect John A. Bruck gave the building an art deco design. It was turned into a junior high school after the new high school was built. It has since been added on to, as seen in the photograph below of its rear. Nowadays the school holds about 650 students in grades 6–8. Scott Clifford is the principal.

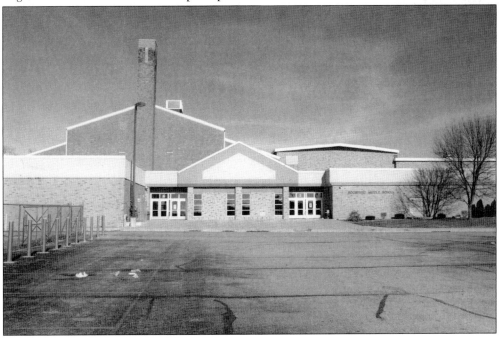

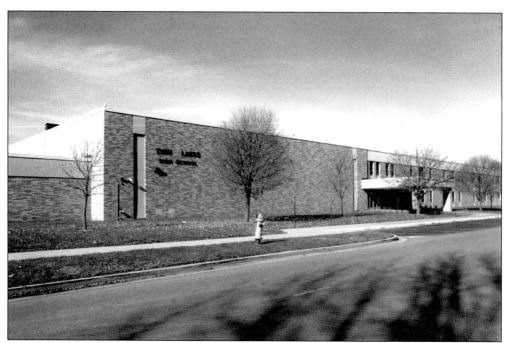

Twin Lakes High School opened in January 1969. The tornado dealt it a severe blow in 1974. An addition to the school was built in the early 1990s. Below is the logo used by the school. The Indians originated back in the 1940s at the old Monticello High School. The school has one state championship to its credit as the girls' softball team won a title in 1989. The 1903 Monticello football team tied for the mythical state title in a scoreless game against Logansport. Today about 825 students attend the school. Keith Braker is the principal.

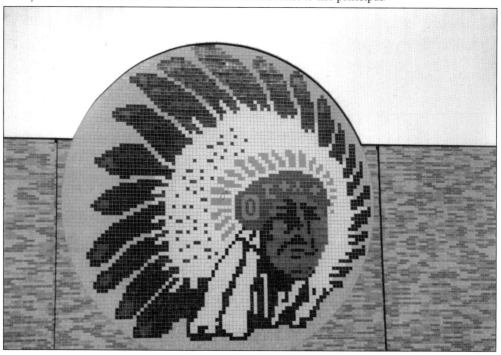

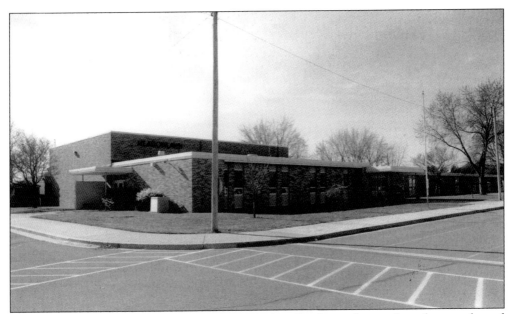

Meadowlawn Elementary School was built in 1963. It suffered some damage from the tornado, and additions to the building were built in 1975 and 1989. The school now serves about 420 students in kindergarten through fifth grade. Alan Jackson is the interim principal. The school has a special program for the special needs children. It also has a reading recovery program for kindergarteners and first graders. A literary collaboration puts emphasis on literature too.

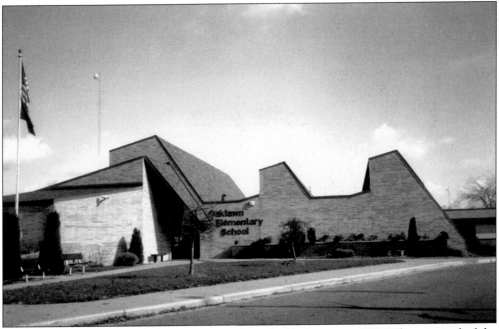

Oaklawn Elementary School was built in 1958 and added on to in 1982. The principal of the school now is Jennifer Lingenfelter. Today it has about 312 students. The school received a grant four years ago to improve reading scientifically to children in kindergarten through third grade. The results have been nothing short of great, according to Diana Crawford.

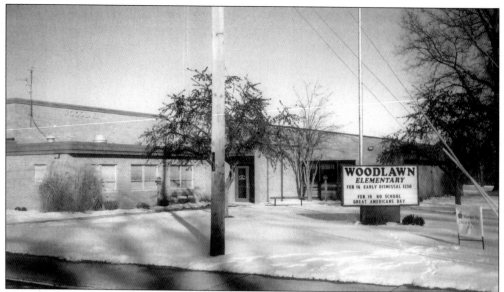

Woodlawn Elementary School, located on the north side of Monticello, was built in 1950. Today it serves 254 students. The school has an active outdoor education center funded by a grant. It received an award in 2006 for three consecutive years of improvement on the Indiana Statewide Testing for Educational Progress (ISTEP) by the Indiana Institute of Achievement. Gloria Kinnard is the current principal.

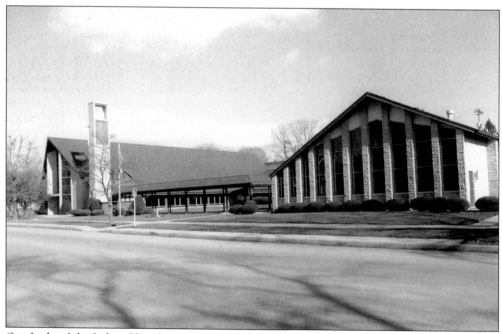

Our Lady of the Lakes Church on South Main Street began services in 1947 in the basement, now used as classrooms. The chapel on the left was built in 1964. The congregation has grown to some 450 Catholics. Fr. James R. Goodrum has led the church the last 25 years. The Catholics first built a small church in Monticello in the 1880s.

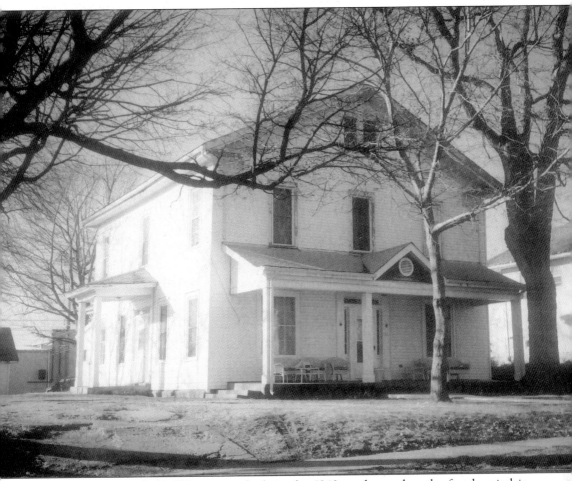

This house on North Bluff Street was built in the 1840s and served as the first hospital in Monticello. Today it is used by St. Mary's Episcopal Church and Grace House. The church moved into the building six years ago. Pastor Sue Blubaugh from Rensselaer conducts service on Sunday mornings. Half of the first floor serves as a church, while the remainder is a women's shelter. Grace House is supported by a committee made up by many churches and other organizations in the community. The house got its name from a little girl who had no place to go and was in need of open-heart surgery.

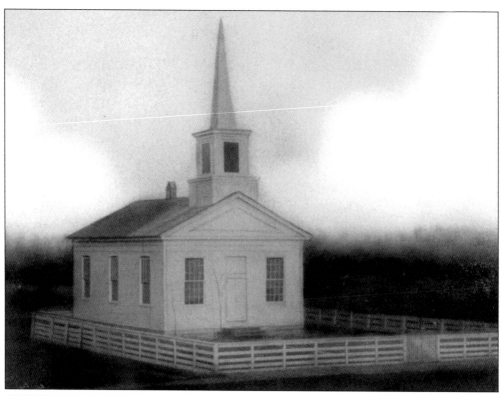

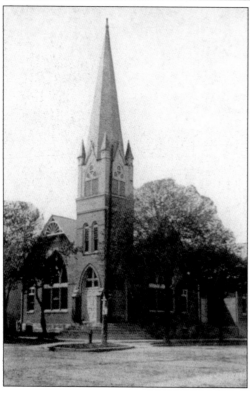

The First Methodist Church was built in 1850 at the corner of Main and Marion Streets. The wooden framed church had one big room, a gallery, and a rostrum. In addition to church services, a Sunday school was organized for youngsters. The church filled the needs of the congregation until 1887, when a new church to the left was built. The old church was sold to the Christians. The cornerstone for the present Monticello United Methodist Church was laid on July 14, 1887, at the corner of Main and Harrison Streets. This 1905 photograph shows the main entrance to the church on Main Street. The steeple and bell tower were removed in 1986. Since then it has undergone a lot of rebuilding to take its present form. Today the church has a membership of about 600 people. (Courtesy Monticello United Methodist Church.)

The Monticello Christian Church built this church in 1902 on Bluff Street after its first church on Main Street burned to the ground soon after the church burned the mortgage. The first church had been purchased from the Methodists. The church went through renovations in 1926 to look like it does today, below. The Christian Church used the building until 1969. It is now owned by Bell Tower Apartments.

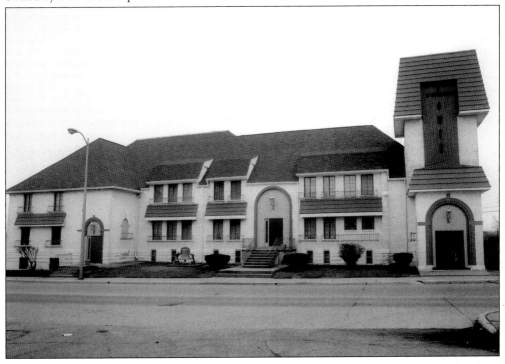

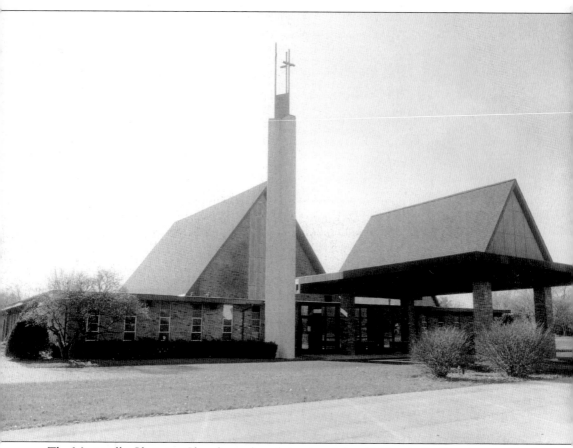

The Monticello Christian Church purchased the site of the old Monticello Speedway and built this church in 1969. The church features three different services on Sunday. It also provides a Bible study, senior adult group, praise team, choir, preschool day care, and supper every Wednesday night. Rev. Chris Dodson has led the church for six years. (Courtesy Monticello Christian Church.)

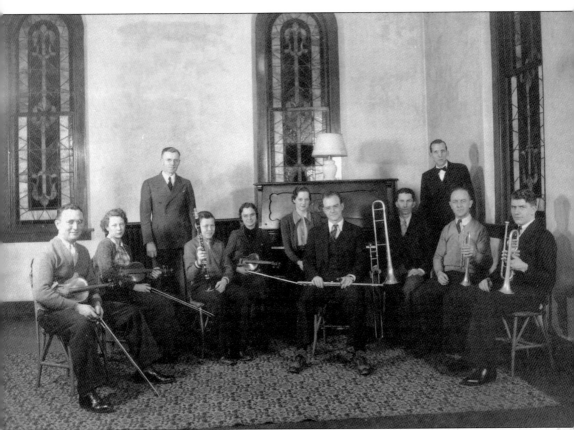

The Crescendo Orchestra of the Monticello Christian Church was organized in the spring of 1936. Roy Weinberg was the conductor, and because he was Jewish, he would not perform during worship services but would play for Sunday school. The orchestra played into the 1940s. (Courtesy Monticello Christian Church.)

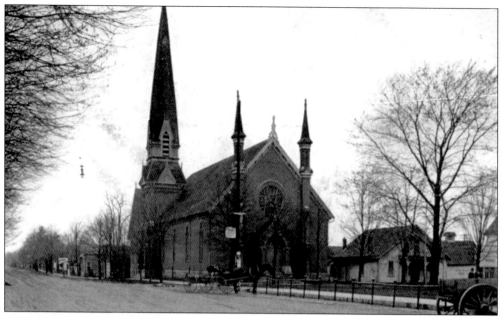

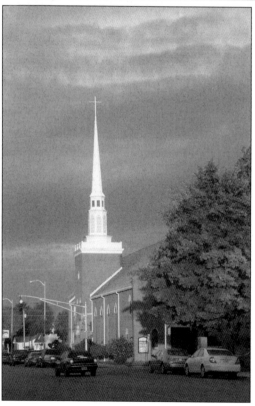

This First Presbyterian Church on the corner of Broadway and Illinois Streets was first completed in 1886, but Presbyterians started meeting in 1836 in a log cabin west of Monticello. The church was destroyed by the 1974 tornado and was rebuilt as seen in the photograph at left. Then in 1988, the north education wing was destroyed by fire. Today, besides traditional church services, the church has a number of teams to spread the word: Congregational Life Team, Mission and Outreach Team, Spiritual Life Team, Christian Nurturing Team, and deacons. The church also provides education: preschool class, elementary class, middle school class, and serendipity class. Rev. Bruce Hurley is the present pastor. (Above, courtesy City of Monticello; left, courtesy Jerry's Photography.)

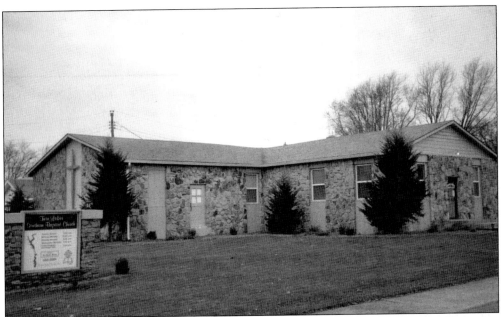

The Twin Lakes Southern Baptist Church moved into this building on Poplar Drive in November 1999. The church was formed in October 1993 and rented a store at 109 North Main Street. The church has grown to about 200 followers now. Besides regular church service and Sunday school, Bible study groups and a vacation Bible school are offered. Rev. W. Ross Terry leads the church.

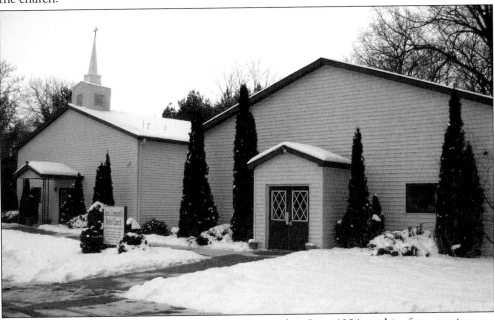

The Grace Community Baptist Church was chartered in June 1984, and its first meeting was at the armory in July. In August, the church started meeting in the American Legion hall. In April 1986, the church purchased the building on the right, which was a union hall for the RCA plant. The chapel addition was built in 1993. The congregation has about 100 members. Gary Roberts is the pastor.

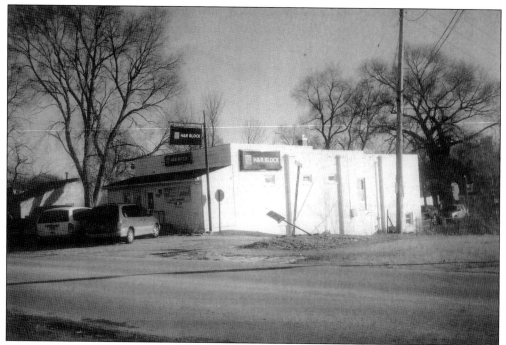

The First Baptist Church of Monticello first began services in this building on Washington Street in East Monticello in 1957. The Venice Mowrer Building is now occupied by H&R Block, which has been there for some 20 years. The church moved into its current building on Beach Drive on February 1, 1966. The church, with about 130 members, has Dr. Howard Ness as its current pastor.

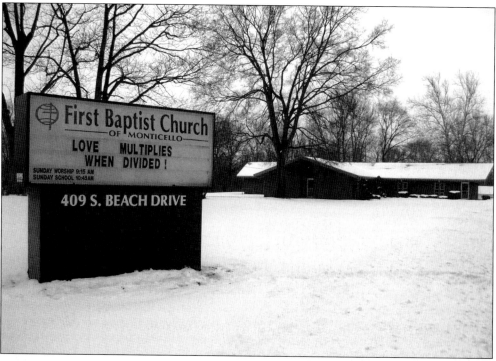

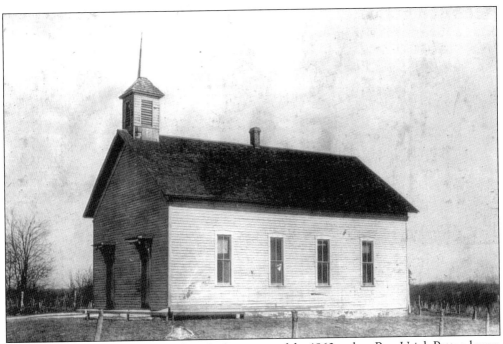

The Zion Bethel Church dates back to the latter part of the 1860s, when Rev. Uriah Patton began preaching to the early founders who were attending Sitka Baptist and Ious Chapel. Around 1900, church members decided to establish their own church and began meeting at the church above, which was located at the corner of East Shafer Drive and Country Road 400 North. That church is now the home of Amana Baptist Church. The Zion Bethel Church moved into the building below at Third and Ohio Streets in 1990. In 2000, the church built a family center that sits next to it. The church has some 200 members now. Jeff Messer has been the pastor of the church since 1983. Besides Sunday services, the church has Bible study groups, a teen club, a men's fellowship, and other activities.

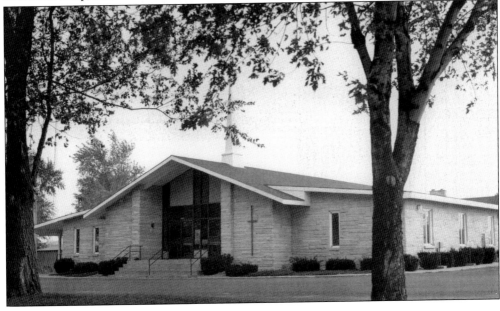

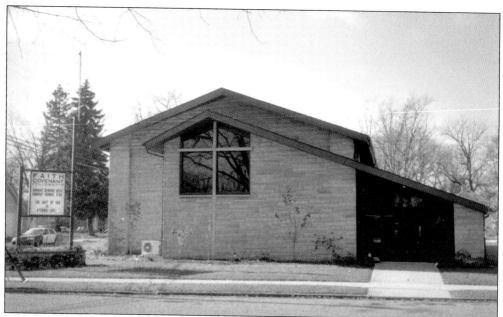

The Faith Covenant Fellowship Church on South Maple Street started worshiping in this building about six years ago after it was purchased from the Church of the Nazerene. The church was built in 1953. The Faith Covenant Fellowship Church began about 13 years ago and met in the Seventh-Day Adventist church building. The church offers Sunday school and services and a Bible study. Pastor Darl Clemons leads about 80 members in worship.

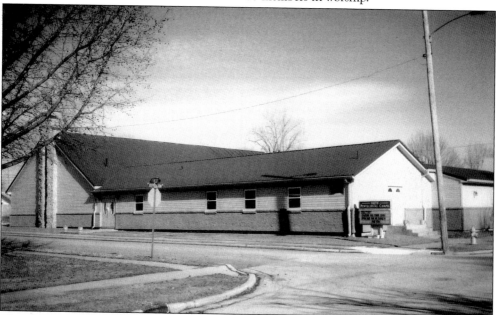

The Faith Pentecostal Church moved to this location in the 1960s in a smaller building. It has been added on to twice in the last 17 years. The church started as the Zion Tabernacle Church in East Monticello in the 1940s. The pastor today is Joe Wampler. The church offers Sunday school and services as well as adult Bible study and children's church. It has a congregation of about 100.

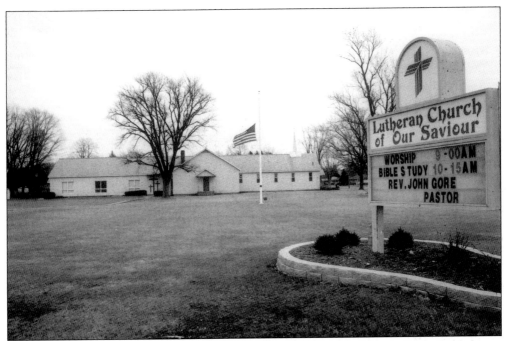

The Lutheran Church of Our Saviour celebrated its 50th year in Monticello in 2007. It was chartered in 1948, but it took another 10 years before the church was built. Today the church has a congregation of about 100 followers and is led by Rev. John D. Gore. Besides Sunday service, the church offers a Bible class, catechism, and a braille workshop.

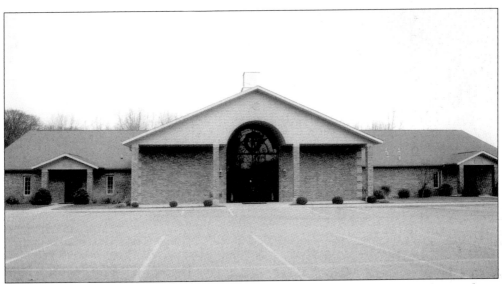

The Calvary Temple of Monticello was established on September 12, 1993, and ground was broken for the church in August 1995 at the West Broadway Street location. Rev. J. L. Shaffer founded the church; he passed away on July 14, 2005. The church has about 120 members in the congregation. Besides Sunday service, it has a men's meeting, women's meeting, youth meeting, and Bible study.

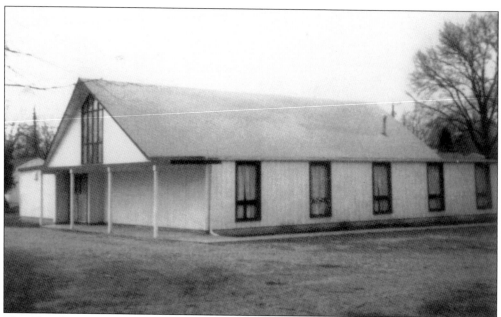

The Church of Christ built this church on the corner of Railroad and Market Streets in 1961. It was destroyed by the 1974 tornado, and the current structure was built. The church traces its beginnings to the living room of Helen Kraack in 1956. Now the congregation has dwindled to about 22 members. It holds two services on Sunday, a Thursday service, and Bible study. (Courtesy Church of Christ.)

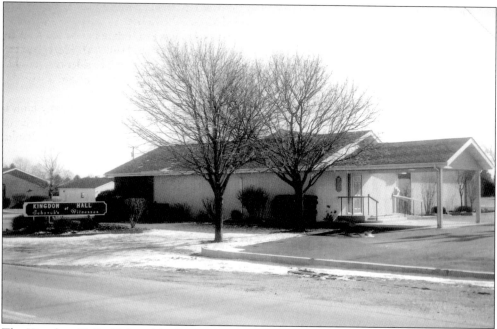

The Kingdom Hall of Jehovah's Witnesses is located on Gordon Road. Its roots go back to the 1940s when its members used to meet at the corner of Main and Broadway Streets. This building was constructed in 1971. It currently has about 100 members, and Bob Clendenen is the presiding overseer. It has a public Bible talk, Watchtower study, ministry school, and service meeting.

Five

THE TWIN LAKES

The first dam built across the Tippecanoe River came in 1833. It was built by Hans Erasmus, a Norwegian. He purchased about 1,000 acres in the area, which later became known as Norway for the Norwegians who settled there. He then constructed a sawmill. A decade later in April 1843, he leased all the waterpower of the dam to William Sill of Monticello, except enough to operate his sawmill. Sill paid $150 a year for 10 years. In 1845, Sill erected a gristmill, which persuaded many settlers to locate permanently in the area.

The area was also known as Mount Walleston after a ship that Hans Hiorth served on. Hiorth was one of the first settlers in the area, and after his death, his wife, Bergetta, laid out the town in 1845. Mount Walleston bustled at first and rivaled Monticello in size.

Another early dam builder was Joseph Rothrock, who built a brush dam across the river in 1838 just south of Monticello. He erected a small sawmill there. Then Daniel M. Tilton erected a small carding mill there, but it caught fire soon after and was destroyed. Residents were able to save the sawmill though. In 1849, the Monticello Hydraulic Company put a dam across the Tippecanoe River to use the power of the river for several industries.

A ferry was used to cross the Tippecanoe River until the Norway Bridge Company built a bridge across the river in 1857. Money was raised from local residents, and a toll was charged to cover costs. However, it was swept away by a flood in 1866. In 1872, the Tippecanoe Hydraulic Company was formed and succeeded the Monticello Hydraulic Company.

In the early 1920s, two dams were constructed to control the Tippecanoe River and create Lake Shafer and Lake Freeman. The Twin Lakes brought about development and tourism. In 1993, Lake Freeman was lowered, and remains of Native Americans and pioneers were discovered around Ski Island south of Monticello. Purdue University conducted an archaeological dig, and the artifacts are on display at the White County Historical Museum.

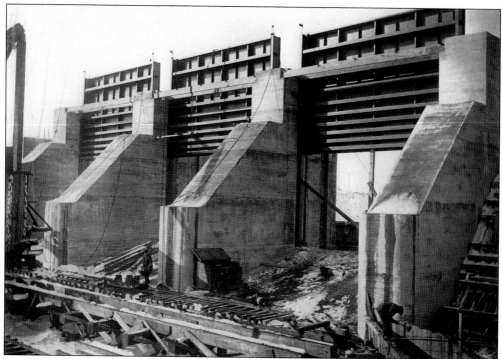

The Indiana Hydro Electric Company of Indianapolis began construction of the Norway Dam in 1921. It was completed in June 1923, creating Lake Shafer, which is an average of 10 feet deep and covers about 1,291 acres. The lake was named after John Shafer, an engineer. He wanted to dam the Wabash River, but it was a navigable river, so he turned his attention to the Tippecanoe River. It is not a flood control dam. Today the dam is controlled by the Northern Indiana Public Service Company. (Above, courtesy White County Historical Museum.)

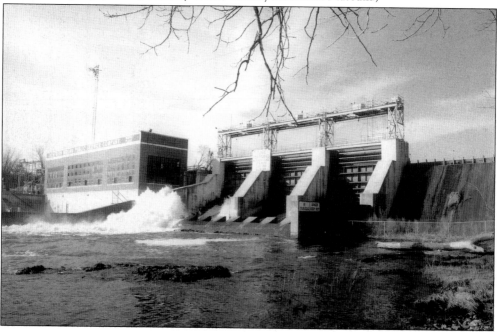

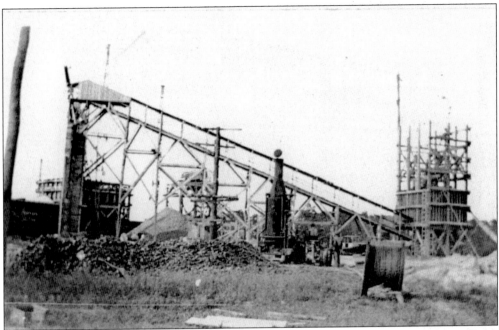

Construction of the Oakdale Dam was completed in November 1925 by the Indiana Hydro Electric Company of Indianapolis. Two workers died during construction. Lake Freeman was named in honor of Roger M. Freeman, an architect who died of an appendectomy operation during construction. Delphi residents wanted the lake named after their city. The area around Oakdale had been used during the Civil War for milling and waterpower. Today the dam is controlled by the Northern Indiana Public Service Company. It keeps Lake Freeman at an average depth of 16 feet that covers 1,547 acres. (Above, courtesy White County Historical Museum.)

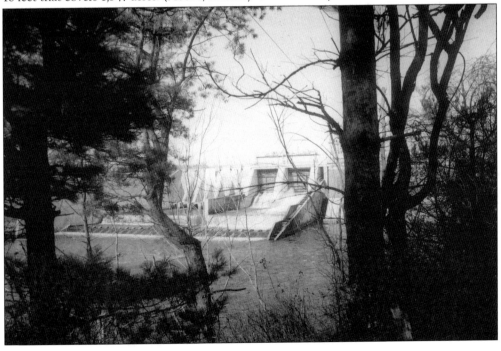

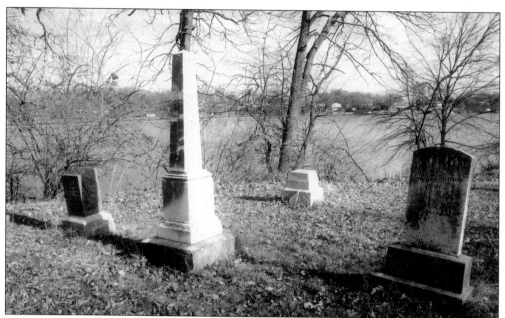

The Norway Cemetery began in the 1800s and is still in use today. The burial of Joseph Esposito Sr., a World War II veteran, took place there in 2006. The cemetery has been used by the county to bury some who have died in the Lakeview County Home over the years. More than 100 graves are located in the cemetery, some of which are unmarked. The Union Township trustee maintains the cemetery.

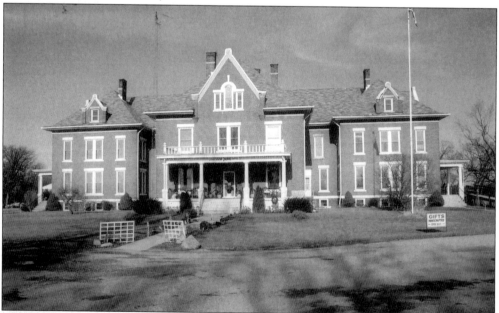

The Lakeview County Home, originally known as the White County Asylum when it was built in 1908, is now a residential living alternative for residents. Designed by architect Samuel Young, it used to care for poor people with no place to live. Nowadays people are totally independent, although some get financial help from the county. They have a computer giveaway program, gift shop, and literacy program. Kae Fuller is the director.

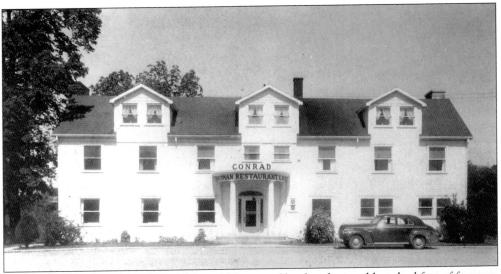

The Sportsman Inn was built in 1928 on 100 acres of land and several hundred feet of frontage on Lake Freeman. Some acres were used for a nine-hole golf course. When the Depression came, the Sportsman Country Club became idle until 1934 when Roy Conrad took a one-year lease and began buying it. In the early days, it was open 24 hours a day with "all you can eat catfish" for a quarter and beer for a nickel. Many celebrities, such as boxer Joe Louis, were welcomed at the hotel, as were politicians from both parties. The historic Sportsman Inn has gone through several owners since Conrad passed away in 1984. The hotel was renovated in 2006 by new owner Fred Ennis and is now only a restaurant. Below is what it looks like from Lake Freeman, where boaters can hook up and go to the restaurant. (Above, courtesy City of Monticello.)

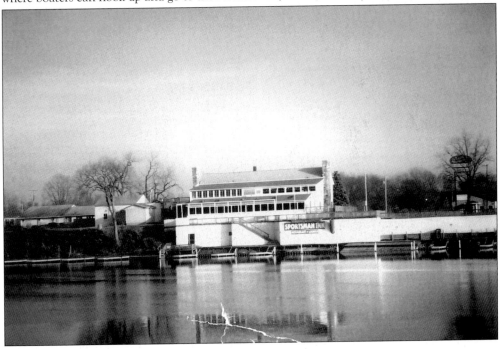

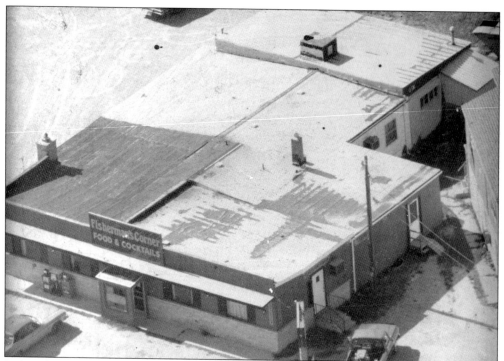

Before the Cottage Shops and Country Clutter, this building across from the south entrance of Indiana Beach was Fisherman's Corner, a restaurant specializing in cocktails and fish dishes. The building was connected to the two-story building, a former filling station, next to it. Now about 35 vendors have their wares for sale in the building. It is believed to have been built during the 1930s. (Courtesy Cottage Shops.)

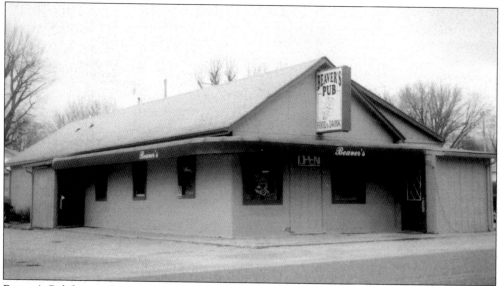

Beaver's Pub has undergone many renovations since it was a store owned by J. D. Rice in the early 1900s. In fact, Bent Cohee used to sell goods from his huckster wagon at the site before then. Rick Przborski purchased it in October 2006 and opened it up for year-round business, serving lunch and dinner.

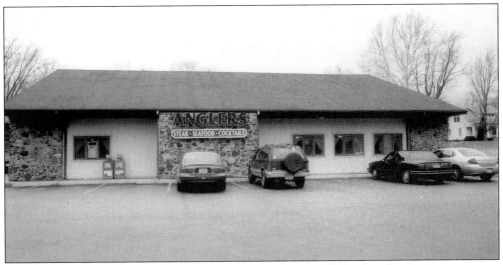

Anglers Restaurant first opened for business in Norway in 1978 after the previous structure burned down in 1977. The current owner is Mike Kalogeras, who bought the restaurant six years ago. The spot has been a place for a restaurant for a century. The first restaurant there was Fisher's Inn, owned by Harry "Fuzz" Arrick. Then it became Fisherman's Paradise, owned by Horace Templeton. The Paradise burned down on November 16, 1950.

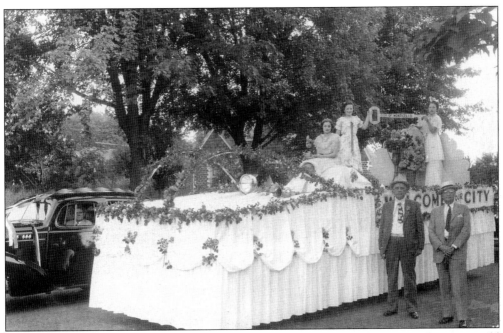

Fishing has always been popular around Monticello, and back in the 1930s, the city would give a key to the city to the fishermen to open the season, as seen in this photograph. Mayor Anthony A. Anheier is pictured next to the float. The girls on the float include Ona Mae Doctor, Helen Meeker, and Louise Ireland. (Courtesy White County Historical Museum.)

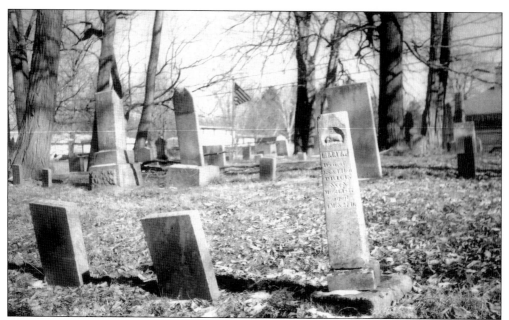

The Britton Cemetery located on Airport Road contains the remains of people who lived south of the city in the 1800s. While there are 80 headstones, there are likely some unmarked graves as well. Families buried there include the Rothrocks, McCollochs, Cochells, Bartleys, Snyders, and Smiths. The cemetery is maintained by the Union Township trustee. Many people call it the Rothrock Cemetery because so many of them are buried there.

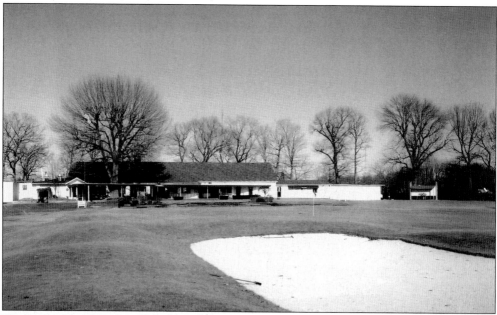

The Tippecanoe Country Club was founded on March 6, 1896, as a nine-hole course. About 1,000 people watched a group of golfers tee it up that day. The first clubhouse was built in 1922 before the Norway Dam was built. Then in 1963, the famed Indianapolis golf course architect Pete Dye helped install greens and tees to bring the course up to 18 holes. The course is 6,728 yards and a challenge to golfers. The course is open from March through November.

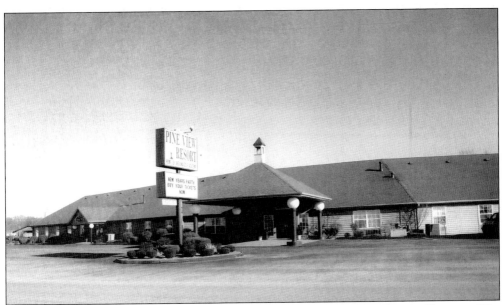

Pine View Resort has 75 rooms, a banquet facility, a conference center, and two golf courses. The par three nine-hole course is located behind the resort and is lit at night during the summer. The original resort was built in the 1970s, and the new resort was built in 1996. Trio's Restaurant is located next to the resort and owned by Denise Marmolijo. The Indiana Golf Academy is run there during the summer. The Pine View Clubhouse below was once a racquetball court located next to the resort. It was moved in 1985. Golfers come to play the challenging 6,876 18-hole course, with seven ponds, numerous sand traps, and hundreds of trees. The course was built in 1979 and bought by the Bonnells in 1985. Pete Dye did not design the course, but he once teed it up there. This is the home course for the golf teams of North White and Frontier High Schools.

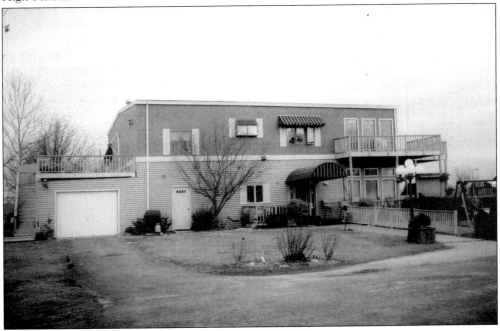

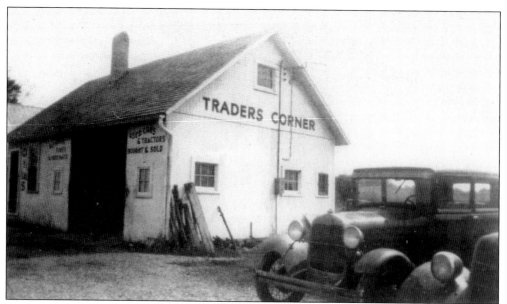

Traders Corner was located at the corner of the Cornbelt Trail (now Indiana 24) and Buffalo Pike (now Indiana 39) east of Monticello in the 1930s and 1940s. It sold used cars and tractors. (Courtesy White County Historical Museum.)

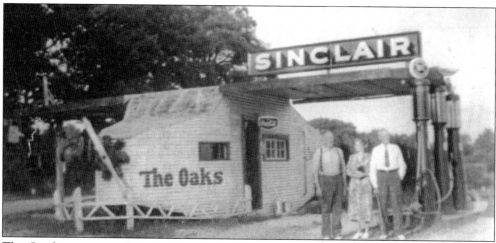

This Sinclair station and the Oaks were located on the Cornbelt Trail (now Indiana 24) to the west of Monticello back in the 1920s. (Courtesy White County Historical Museum.)

One of the first cemeteries in the area was the Sheetz family cemetery in East Monticello, high on a cliff overlooking the Tippecanoe River. A dozen graves there hold the remains of Zebulon Sheetz and family members, as well as a couple of Thompsons and Eva Oates. It was restored by the First Presbyterian Church Youth Group and Don Purkhiser some years ago. Today the cemetery is owned by Steve Buschman. (Photograph by Jan Lindborg.)

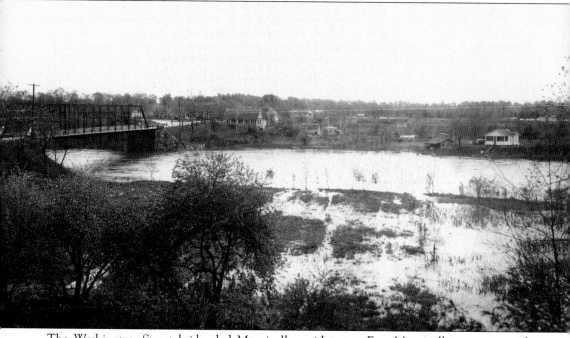

The Washington Street bridge led Monticello residents to East Monticello, as seen in this photograph taken in 1936. James C. Reynolds plotted 28 lots in East Monticello in January 1867. After Lake Freeman was created, East Monticello became more populated since flooding was no longer a threat. Sewer lines will soon be added to the area. (Courtesy White County Historical Museum.)

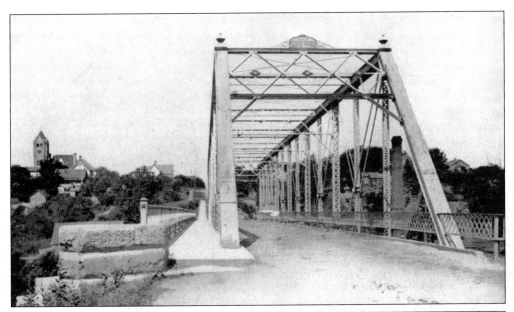

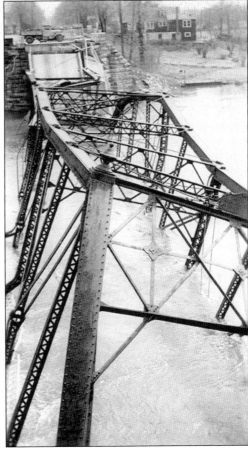

The postcard above shows Monticello as seen from the Washington Street bridge, built in 1898. Note the old courthouse in the background. The 300-foot span served East Monticello until March 20, 1946, when it collapsed as seen to the right. Nobody was hurt when it fell, but two boys and a man had just crossed it. The bridge had been closed for a month prior to collapse. The first bridge to span the Tippecanoe River by Monticello was in 1856 by the Monticello Bridge Company. The present bridge was constructed in 1948. (Courtesy White County Historical Museum.)

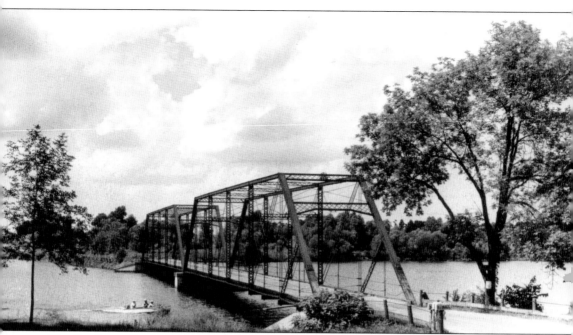

The first Lowes Bridge was built in the 1880s. It was replaced in 1970 with the present bridge, which was constructed for $350,000. It is just south of the Norway Dam and provides access to the east side of Lake Shafer. (Courtesy White County Historical Museum.)

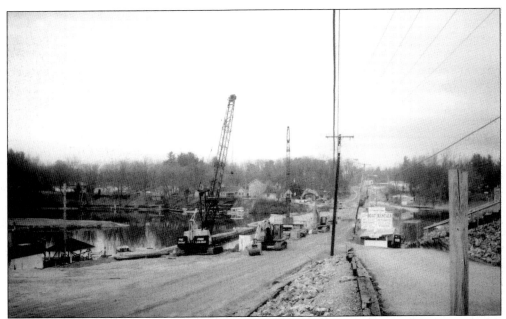

Roadwork began on improving the traffic pattern and safety to Indiana Beach, as seen in this photograph of work at the Honey Creek Bay Bridge. The bridge was scheduled to reopen by the time Indiana Beach opened for 2007. Three and half miles of Sixth Street and West Shafer Drive will be widened in the four-phase construction project. The city and amusement park have wanted this for years to decrease traffic congestion.

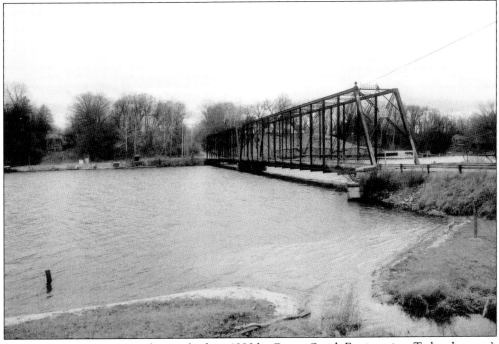

The wrought iron Tioga Bridge was built in 1890 by Craver Smith Engineering. Today the state's longest whipple bridge is in need of a face-lift, which it should get in 2007. It may be lifted as well to allow more boats to pass under it. It has been closed to traffic since the mid-1980s.

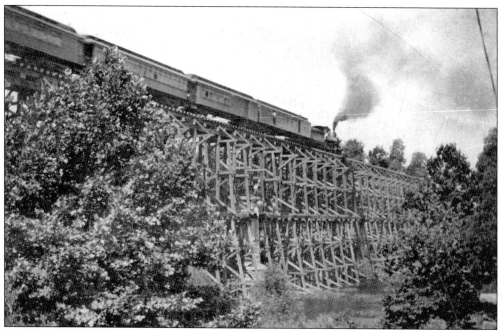

This picture shows the false woodwork used before the new steel structure could be completed for the Chicago and Delphi, the second railroad to go through Monticello. The railroads made it possible for livestock and grain to be shipped to distant points. The route later became the Monon Railroad. The bridge was taken down in the 1990s after the Monon quit running in Monticello. (Courtesy White County Historical Museum.)

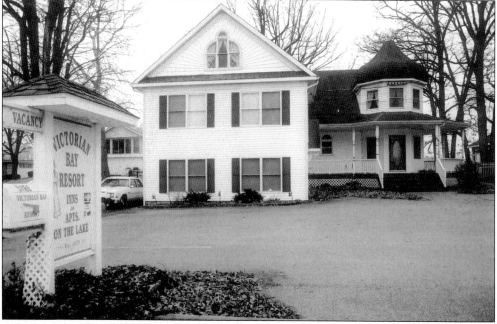

After Ideal Beach was started in 1926, several resorts popped up nearby to take advantage of the resort area. Victorian Bay Resort was one of those as it was built in 1929 and still serves visitors to Indiana Beach. It is conveniently located a stone's throw from the amusement park.

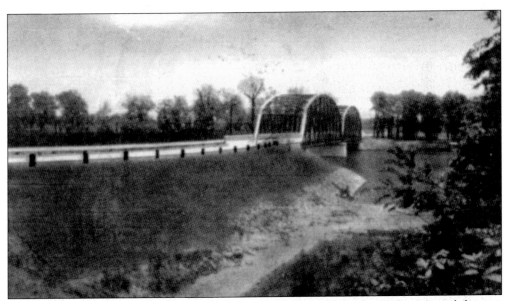

In 1889, this two-span iron bridge was built to serve Indiana 39. In the 1930s, it served the new Indiana 421 as well. The bridge stood until a new one was built in 2001. It was built by Jack Isom Construction. The new bridge was named the Captain Bill Luse Bridge on April 18, 2004, in honor of the ship captain of the *Madame Carroll*. He passed away in 2003. (Courtesy White County Historical Museum.)

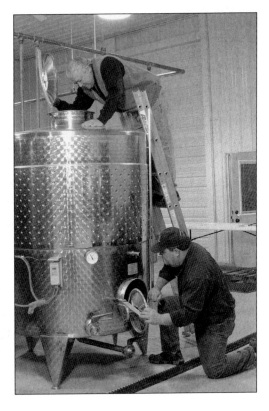

Larry (top) and Don Pampel work on making wine at the new Whyte Horse Winery south of Monticello on Airport Road. The family-run winery was built inside a renovated 1886 farmhouse. The Pampels have a couple of vineyards to provide the grapes necessary to produce their products. The wines are served at the Sportsman's Inn. The winery is an addition to the growing tourist industry in the area. (Courtesy Jerry's Photography.)

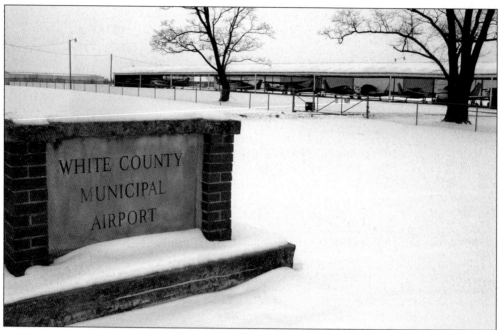

An airport for Monticello was first discussed in the late 1920s, but it did not come about until 1945. At one time the airport provided rides for a "penny a pound." A 500-foot expansion in 1984 allowed for small corporate jets to land at the airport. Now the airport is being managed by Terry Dill. A new hangar was added in 2001.

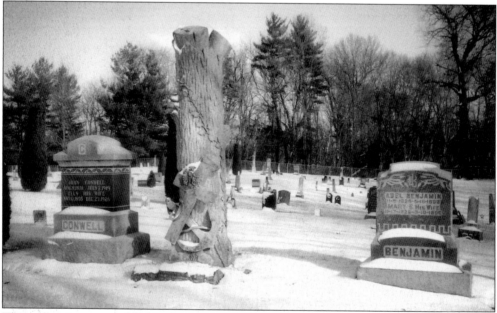

This tree monument in Hughes Cemetery marks the grave of William R. Connell, who died in 1908 at age 17. The short tree represents that his life was cut short. Hughes Cemetery is located near Country Road 600 East and Country Road 600 North between Indiana 39 and Lowes Bridge about five miles from Monticello. The cemetery dates back to the mid-1800s, and there are many Civil War veterans.

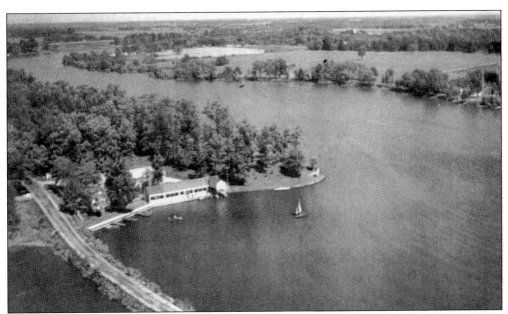

Tall Timbers began selling and servicing boats on Lake Shafer in the 1940s. There were not that many homes on the lake back then, as seen in this photograph. The company has gone through several ownerships, and today it is owned by Mike Creigh, whose family has had the place for about 20 years. The business opened a new location (below) in East Monticello the year after the tornado of 1974. (Above, courtesy Tall Timbers.)

The DeFabis family plot is the most extravagant in the Riverview Cemetery, which is owned by IOOF Lodge No. 107. Louis DeFabis was born in Rome, Italy, while his wife, Alice P. Panbyote, was born in Greece. Another interesting feature is the 3,500-pound boulder below that sits on the grave of W. A. Hardy. It contains the inscription, "Ike Walton of the Tippecanoe" and sits on the ridge overlooking the horseshoe bend in Lake Freeman. More than 6,700 people are buried in the cemetery, which dates back to the late 1800s. More than 600 of them are military veterans. It is the most-used burial grounds in the area, and the IOOF has moved its headquarters there. The fraternal organization has 36 members and supports the Arthritis Foundation and a float in the Rose Bowl every year. The IOOF may be the oldest fraternal organization in Monticello. It may be one of the oldest in the world, as legend traces its beginning to ancient Rome.

Six

INDIANA BEACH

Businessman Earl W. Spackman saw an opportunity to begin a resort after people kept asking him where there might be a good spot to swim. So he brought in sand and gravel to create a beach where a cornfield had once grown. The peninsula where he began the beach was known as Untaluliti, a Native American word meaning "lodge by the lake." In 1926, he opened Ideal Beach, named after his company, Ideal Furnace Company of Indianapolis. He began with a pop stand and a beach. Spackman also sold 62 lakefront lots to interested buyers. The following year he added a hotel called the Beach House with 24 rooms and a dining room. Ideal Beach grew in popularity.

While the nation went through the Depression in the 1930s, Ideal Beach continued to attract vacationers by lowering prices and adding more features. Vaudeville acts and bands performed. A pier was built in 1935, but it was damaged by ice and had to be rebuilt in 1937. The famed Duke Ellington's Orchestra played there in 1937 to a large crowd. The *Fairy Queen* excursion boat was added in the 1930s to take tourists around Lake Shafer. In 1941, the first concession, a miniature golf course, was opened and others followed. Benny Goodman and his famous orchestra also appeared in 1941. After the war, Ideal Beach was incorporated. Spackman died the same year and passed the beach onto his son, Tom Sr.

In 1951, a new Beach House Hotel opened with 42 rooms. The beach also had 48 cottages and apartments. The name was changed to Indiana Beach in 1951. Since then Indiana Beach has transformed itself from a beach with a dance floor into a top-notch entertainment park with roller coasters, rides, restaurants, concessions, games, and so on. There is something for everyone. The park now has more than 50 attractions. Its philosophy has been to provide good service to everyone who comes so they will come back. It also has added new attractions every year to make the park fresh to return patrons. As I. B. Crow says, "There's more than corn in Indiana."

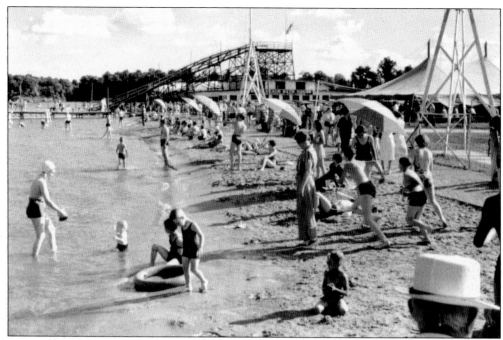

Swimmers enjoyed Ideal Beach right from the beginning. This photograph from the 1930s shows the water toboggan slide in the background. It was rebuilt in 1937 with a double track. The slide is no longer an attraction at Indiana Beach. (Courtesy Indiana Beach.)

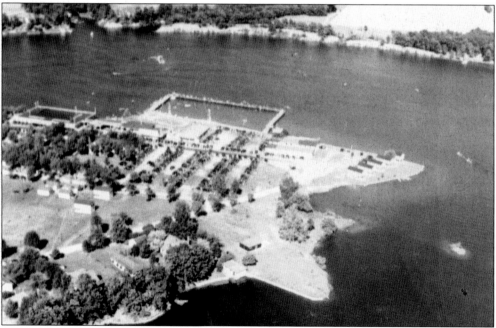

This 1940 photograph shows what Ideal Beach looked like from the air. This was before the submerged island was raised to the south to create more space for the entertainment park. It was dubbed Paradise Island. The area on the opposite shore of Lake Shafer was not developed much back in 1940 either, as seen in this photograph. (Courtesy Indiana Beach.)

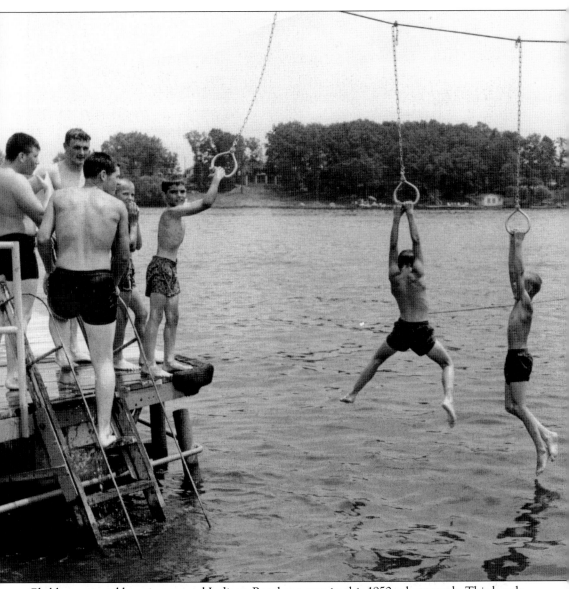

Children enjoyed hanging around Indiana Beach, as seen in this 1950s photograph. This beach attraction has gone by the wayside and been replaced by more sophisticated water attractions. During the 1950s, Billy Haley and the Comets performed at Indiana Beach. (Courtesy Indiana Beach.)

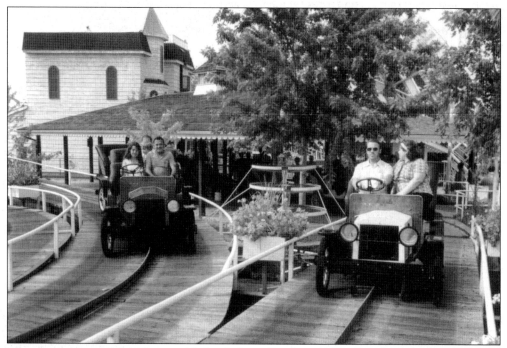

The antique automobile ride was added to Indiana Beach in 1965. The vehicles resemble the old Ford Model T that was the most popular car during the early 1900s. The ride still attracts lots of riders today. (Courtesy Indiana Beach.)

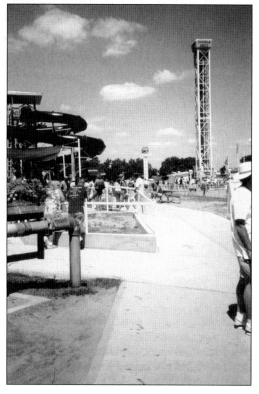

The Double Shot attraction was added to Indiana Beach in 1999, the same year that the Frog Hopper was added. The ride takes people high over Indiana Beach before slamming them back to the ground. It is not for the faint at heart. (Courtesy Indiana Beach.)

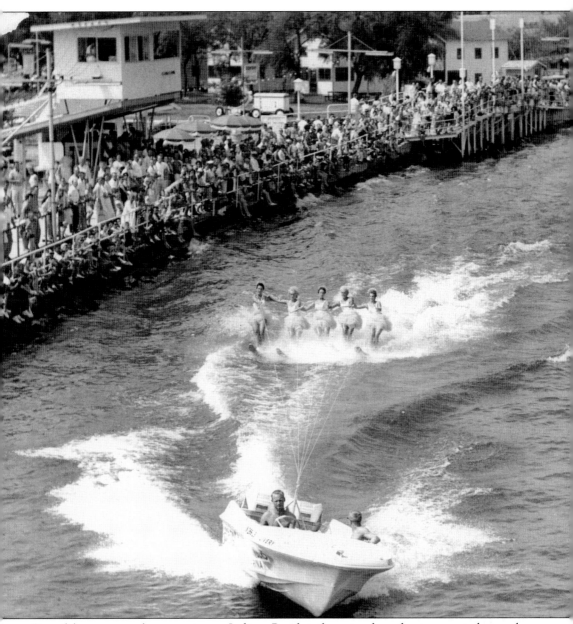

One of the most popular attractions at Indiana Beach is the water show that is presented a couple times a day to customers at no charge. Water shows have been popular there since the 1950s. Another popular attraction is the Fourth of July fireworks show, and Indiana Beach provides an ideal spot to watch the fireworks. (Courtesy Indiana Beach.)

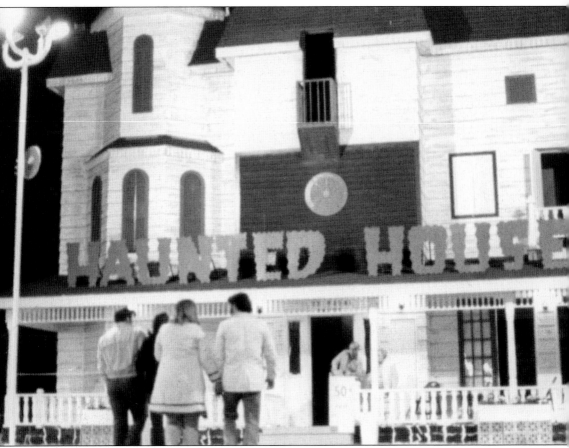

The haunted house began operating in 1969, the same year that the Mystery Mansion dark ride began. Pay-one-price ride sessions began that year too. The haunted house burned down in 1980 and was rebuilt as Dr. Frankenstein's Haunted Castle in 1983 with steel and cement blocks on the old site of the first haunted house. (Courtesy Indiana Beach.)

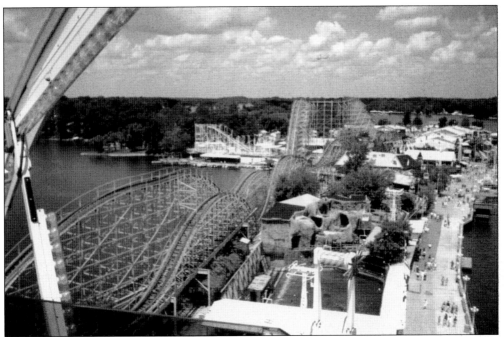

The Hoosier Hurricane wooden roller coaster was built in 1994 for $4.5 million. The coaster became an immediate hit with riders. The Sky Coaster was added the following year. (Courtesy Indiana Beach.)

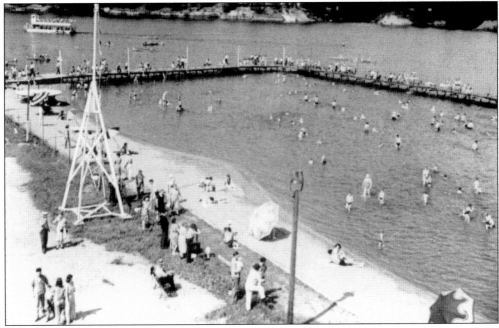

This photograph of Ideal Beach shows the 12-foot-wide, 650-foot-long promenade pier built around the bathing beach in 1937. It kept swimmers in and boaters out. That same year the dance pavilion doubled in size to 6,000 feet and a roll-back roof was installed. (Courtesy Indiana Beach.)

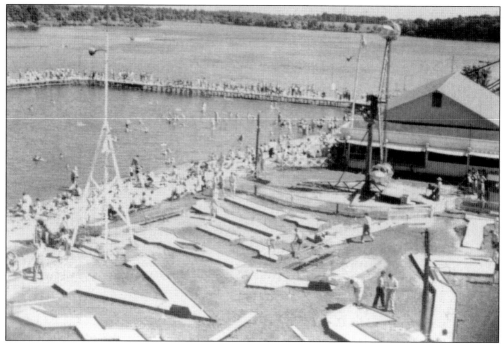

The first miniature golf course was added to Ideal Beach in 1944. That was the same year archery was added. The water merry-go-round was featured at the bathing beach that year too. Another miniature golf course was built on Paradise Island in 1956. (Courtesy Indiana Beach.)

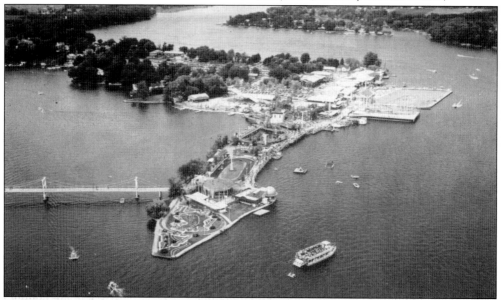

While the Norway Dam was being built, former Monticello mayor Thomas W. O'Connor decided to capitalize on the coming lake and developed what he believed was going to be an island. He had truckloads of rock, broken concrete, and soil brought in. Unfortunately, he miscalculated, and when Lake Shafer filled up, the area was underwater. In 1954, Indiana Beach capitalized on his miscue and built up the area to create an extension to the original peninsula, as seen in this 1970s photograph. (Courtesy Indiana Beach.)

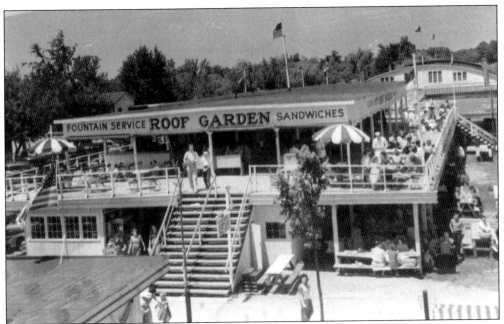

The Roof Garden was built after the Ideal Beach Casino (ballroom) was destroyed by fire on the opening morning on May 30, 1930. It was originally known as the Dance Garden. One of the attractions in the 1930s was the Great Pasha, who drove a car blindfolded and remained in a vault for two hours. (Courtesy Indiana Beach.)

The *Shafer Queen* paddle-wheel passenger boat was first introduced in 1966. This larger, faster *Shafer Queen* was launched in 1973. The old one was turned into the Pronto Princess floating restaurant, which is still in use today. In the 1940s, the *Fairy Queen* excursion boat took customers around the lake. (Courtesy Indiana Beach.)

The sky ride gives customers a great view of Indiana Beach and the surrounding area. It was first installed in 1965. That was the same year that the Indiana Beach Campground first opened. Bumper cars and antique automobiles were also added that year. Rides cost a quarter back then. A few years later, the Who appeared at Indiana Beach to the delight of many rock fans. (Courtesy Indiana Beach.)

The Tig'rr Coaster whirls couples around in small cars on a rail to give them a great thrill ride. The ride was added in 1984 and still thrills riders today. (Courtesy Indiana Beach.)

Tom Spackman Sr. monitors the construction of Superstition Mountain in 1976. The ride opened two years later. Then in 2002, the ride was converted into a coaster ride. Spackman, now in his 90s, took control over Indiana Beach when his father passed away in 1946. He was named a Sagamore of the Wabash in 2000. He has since turned over the day-to-day operation to his son, Tom Jr. (Courtesy Indiana Beach.)

This scaling wall has become a popular attraction nowadays at Indiana Beach. Since 2000, the amusement park has added the Cornball Express, Air Crow, Splash Battle, and Water Splash Play Area. (Courtesy Indiana Beach.)

This photograph shows Indiana Beach from a bluff near the south entrance. A suspension bridge connects the south parking lot with Indiana Beach, It was built in 1968 at a cost of $30,000. It is 450 feet in length. (Courtesy Jerry's Photography.)

Seven

MODERN MONTICELLO

The census of 2000 revealed a population of 5,723 people, 2,268 households, and 1,417 families residing in the city. Of that population, about 11 percent were of Hispanic origin and less than 1 percent African American. The median income for a household was $35,537.

In 2000, Monticello grew in size with the annexation of property where Wal-Mart, Best Western, and Sycamore Estates were located. On July 23, 2004, a groundbreaking ceremony was held for phases one and two of the Twin Lakes Regional Sewer Project to improve sewage in the area.

The year 2005 was marked by another tragedy in Monticello when Jordan Manufacturing burned down in September. The company's outlet store had to relocate to a store on Main Street. Then in 2007 a new warehouse was built on Sixth Street for the manufacturer of outdoor furniture.

On June 1, 2006, about 15 tornadoes were reported in the area, but fortunately there was no repeat of what happened to the city in 1974. After years of waiting, work finally began on road improvements to North Main Street, Sixth Street, and West Shafer Drive in 2006. The improvements will make it easier for residents and tourists to get around the city.

Modern Monticello offers job opportunities at such places as Ball Metal Beverage Corporation, White County REMC (Rural Electric Membership Corporation), White County Memorial Hospital, White County government, several banks, retail stores, automobile dealers, and so on. Besides producing two-piece beverage cans, the Ball company collects donations of aluminum cans and turns the money that they are worth over to the city as a donation. The company employs about 200 and runs 24 hours a day.

About a million people come to the Twin Lakes each summer to enjoy the lakes and attractions. They also come to see the fireworks on Lake Shafer every Fourth of July and the annual Spirit of Monticello Festival in downtown Monticello as well.

In the future, Monticello is expected to continue to grow in both size and population. New condominium and housing projects are scheduled to open around Lake Freeman in 2007.

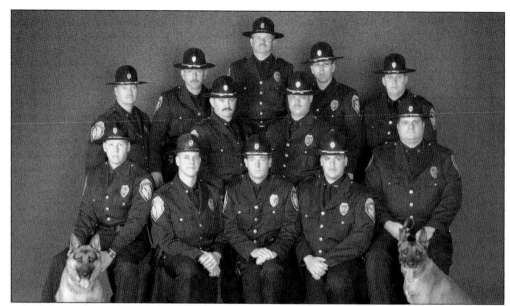

The Monticello Police Department has a dozen officers and two dogs to protect citizens of the city. They are, from left to right, (first row) Kyle Peterson with dog Dan, officer Jason Lingenfelter, officer Tony Stroup, officer Ryan Pyle, and Capt. Curt Blount with dog Shadow; (second row) Assistant Chief Randy Soliday, detective Tim McFadden, officer Mike Andrews, Chief Jim Reynolds, officer Jeff Hunt, officer Thad Miller, and Lt. Nate Miller. (Courtesy Jerry's Photography.)

Galen Logan became the chief of the Monticello Fire Department on February 21, 2005. The Monticello native first joined the department as a volunteer in 1982. The department has 23 full-time, 6 part-time, and 8 volunteer firefighters. Monticello is equipped with fire trucks, ambulances, boats, and the latest equipment. It has rescue teams that are trained in many aspects of saving lives. (Courtesy Jerry's Photography.)

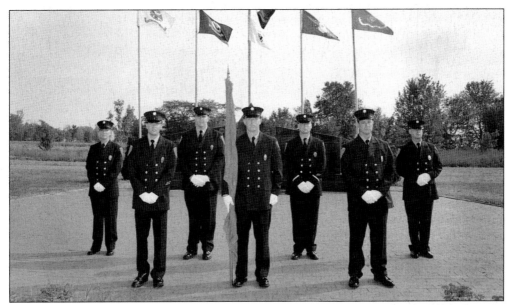

The 2006 Monticello Fire Department Honor Guard includes, from left to right, these firemen: Doug Ward, Jason Anderson, Jason Thompson, Nick Banes, Shane Swaim, Kevin Mohler, and Tresea Fraser. This photograph was used for the 2006 calendar. It was taken in front of the AMVETS memorial honoring veterans from White County who perished in World War I, World War II, the Korean War, and the Vietnam War. POWs and MIAs are also honored. (Courtesy Jerry's Photography.)

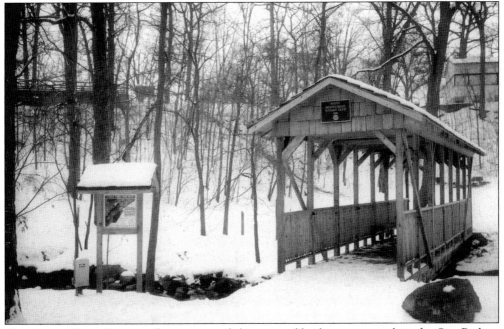

The Rotary Club of Monticello constructed this covered bridge over a creek in the City Park in 2006. The Boy Scouts have also been busy in the park. The lower park tree trail was constructed by Pack 3154. Riley O'Farrell of Troop 154 constructed the sign as an Eagle project. The City Park was first constructed around 1912.

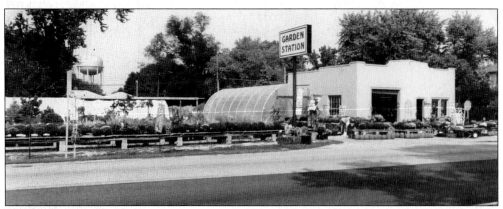

The Garden Station on Broadway Street is now a flower and garden store, but years ago it used to be the OK Tire and Service Station owned by the Mummerts. The station was first built in the 1920s. There is still a gas pump outside, but it is not one of the original ones. The station is now owned by Mike and Betsy Dill, who have been there since 1995.

Congressman Steve Buyer now calls Monticello his home. He was born along the Tippecanoe River north of the city and is a graduate of North White High School in Monon. After getting a bachelor's degree at the Citadel and graduating from Valparaiso Law School, he served in the U.S. Army as a staff judge advocate during the Gulf War. In 1992, he was elected to Congress and has served ever since.

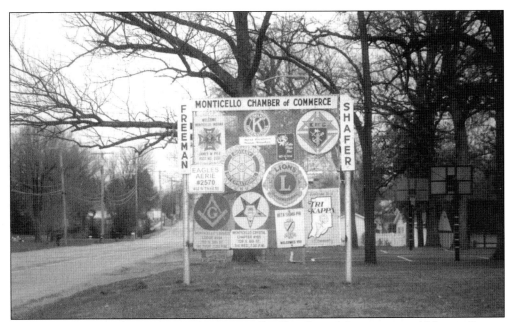

The welcoming sign to the city by the Monticello Chamber of Commerce and Visitors Bureau lists several civic organizations: Veterans of Foreign Wars Post 2231, Kiwanis International (which first met in Monticello in 1937), K of C, Eagles Aerie No. 2570, Rotary International, Lions International, Monticello Libanus Lodge No. 154, Monticello Crystal Chapter No. 165, Beta Sigma Phi, Tri Cappa, and Delta Theta Tau.

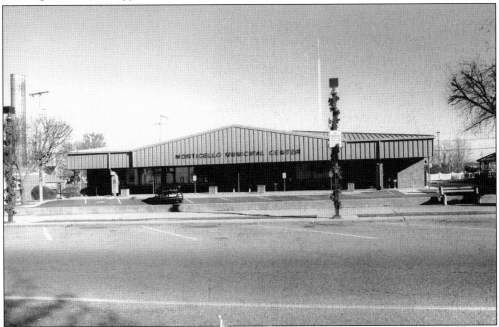

This building was renovated in 1993 by Dimensions Inc. to house the City of Monticello offices. The building now contains the mayor's office, clerk-treasurer, police department, and clerks for the sewage and water department. The building was first constructed after the 1974 tornado and went through several owners before the city bought it.

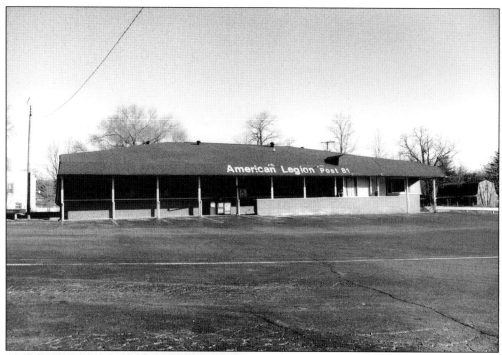

American Legion Post 81 built this structure in East Monticello in 1972. The building was constructed by Church Builders and suffered some damage from the tornado in 1974. Today the Thornton O. Williams Post serves about 550 legionnaires. Post 81 was organized in 1919 by 15 charter members and recognized by the National American Legion on August 1, 1920. The original post was located at 129½ North Main Street in a two-story structure. The legion moved around and in 1947 found itself meeting in the old courthouse. It needed to raise money for a building of its own and invited former heavyweight boxer Joe Louis to fight an exhibition in Monticello. The famed boxer came and drew a huge crowd to raise enough money to purchase the property in East Monticello. The post was named after Thornton O. Williams of Reynolds (left). He joined the U.S. Army on May 28, 1918, and died exactly one year later at Fort Sill, Oklahoma. (Courtesy American Legion.)

AMVETS Twin Lakes Post 91 bought this building in north Monticello in 1991. The post was chartered in March 1989 and rented a space a block away. Now the post is the largest AMVETS post in Indiana, with some 550 members. The organization provides a shuttle service for veterans to Veterans Administration hospitals. It honors POWs and MIAs as well as those who have died in service. AMVETS was formed in 1944.

The Order of the Red Men Lodge 518 began operations in Monticello in 1911 and is now located in this building, which was built in 1968 at a cost of $30,000, on North Main Street. The organization traces its origin to certain secret patriotic societies founded before the American Revolution in 1765. Current membership is about 450 for the Conawaugh Tribe. It is a patriotic fraternity chartered by Congress.

The Audience of One from the Monticello Christian Church Praise Team at the Spirit of Monticello Festival is shown in 2006. Performing are (from left to right) Chad Hostetler, Paula Lantz, and Mark Cramer. The festival also featured a five-kilometer walk, more than 50 vendors, a dunk tank, a pancake breakfast, and other fun activities. The 2007 festival is scheduled for July 27–28. (Courtesy Jerry's Photography.)

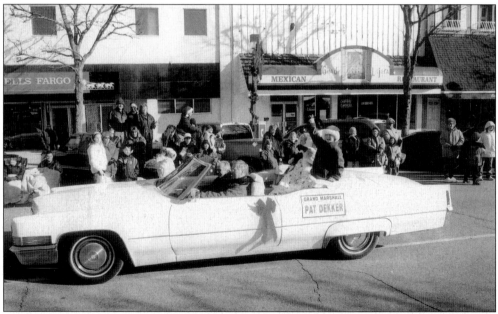

Pat Dekker was the grand marshal for the 2006 Christmas parade. Sponsored by the Monticello Chamber of Commerce and Visitors Bureau, the parade featured more than 60 units, including the American Legion, White County Horse and Pony Club, New Hope Lutheran Church, McDonald's, Twin Lakes High School band, and other businesses, sporting teams, fire departments, scouts, churches, and so on. The theme for the parade was "Countdown to Christmas."

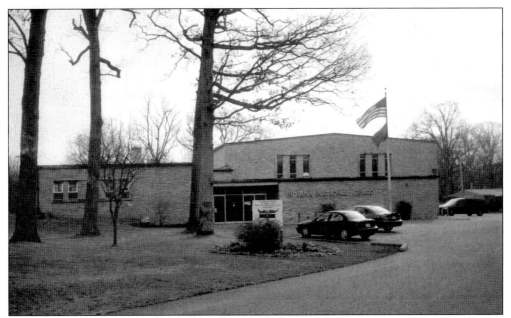

The Indiana National Guard Armory was built in 1963 and now houses the 738th Area Support Medical Company. The unit spent a year in Iraq and treated more than 36,000 wounded and sick soldiers as well as civilians. It also provided medical training to Iraqi soldiers. The unit received three Purple Hearts, 16 Bronze Stars, seven Combat Action Badges, and nine Combat Medical Badges. One soldier was lost—Staff Sgt. Richard Blakely.

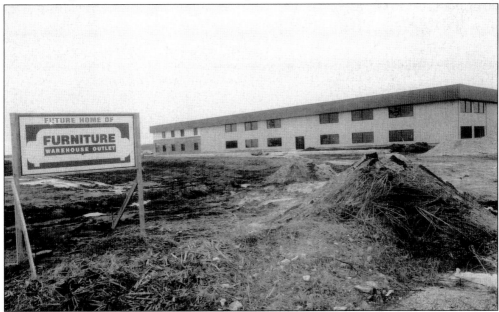

Jordan Manufacturing moved into this new building on Sixth Street in early 2007. The new warehouse also contains a retail outlet. The move came about after a devastating fire on September 5, 2005. Dave Jordan began the business in 1975 in his basement in Peoria. He moved it to Monticello in 1985 after purchasing the old RCA building. The company now has about 200 employees. The company imports patio furniture and makes umbrellas for it.

ACROSS AMERICA, PEOPLE ARE DISCOVERING SOMETHING WONDERFUL. *THEIR HERITAGE.*

Arcadia Publishing is the leading local history publisher in the United States. With more than 3,000 titles in print and hundreds of new titles released every year, Arcadia has extensive specialized experience chronicling the history of communities and celebrating America's hidden stories, bringing to life the people, places, and events from the past. To discover the history of other communities across the nation, please visit:

www.arcadiapublishing.com

Customized search tools allow you to find regional history books about the town where you grew up, the cities where your friends and family live, the town where your parents met, or even that retirement spot you've been dreaming about.